THE NEW TESTAMENT

A Pictorial Archive from Nineteenth-Century Sources

311 Copyright-Free Illustrations

THE CENTRAL SCHOOL OF SPEECH AND DRAMA

UNIVERSITY OF LONDON

Copyright © 1986 by Dover Publications, Inc.
All rights reserved under Pan American and International Copyright Conventions.

Published in Canada by General Publishing Company, Ltd., 30 Lesmill Road, Don Mills, Toronto, Ontario.
Published in the United Kingdom by Constable and Company, Ltd., 3 The Lanchesters, 162–164 Fulham Palace Road, London W6 9ER.

The New Testament: A Pictorial Archive from Nineteenth-Century Sources is a new work, first published by Dover Publications, Inc., in 1986.

DOVER *Pictorial Archive* SERIES

Manufactured in the United States of America
Dover Publications, Inc., 31 East 2nd Street, Mineola, N.Y. 11501

Library of Congress Cataloging-in-Publication Data
Main entry under title:

The New Testament.

(Dover pictorial archive series)
Includes index.
1. Bible. N.T. — Illustrations. 2. Wood engraving — 19th century — Themes, motives. I. Rice, Don, 1938– II. Series.
NE958.N48 1986 769'.484'09034 85-25341
ISBN 0-486-25073-3 (pbk.)

PUBLISHER'S NOTE

The engravings reproduced in the present volume stem from a long history of Bible illustration. Early texts, such as the seventh-century Lindisfarne Gospels, often contained elaborate painted illuminations. These manuscript versions, although slow and expensive to make, were produced for centuries. They were gradually replaced by printed books beginning in the fifteenth century, when the invention of wood-block printing and movable type resulted in mass-produced books, the famous Gutenberg Bible being one of the earliest.

Wood engravings were first used extensively by Thomas Bewick during the last part of the eighteenth century, and they became the predominant means of reproducing pictures during the next hundred years. The illustrations in this book are reproductions from originals found in nineteenth-century publications. Represented here are works by some of the medium's most gifted engravers, including the Dalziel brothers and W. J. Linton. Generally, the technique was as follows. The engraver copied the artist's design in reverse onto a hardwood block cut against the grain. The parts to be printed were left in relief; the rest was cut out. At times the signatures of both artist and engraver appeared on the prints. Sometimes the same picture was copied by different engravers for different publications, resulting in assorted sizes, croppings and levels of quality among reproductions of the same image.

Biblical illustrations have long been useful tools for teaching the scriptures to both children and adults. Since reading proficiency was much lower in the past than it is today, illustrations played an even more prominent didactic role then than they do now. They were also meant to embellish the books in which they appeared. In addition to narrative scenes, designers often used decorative initials, borders, spot illustrations and typographical ornaments with religious texts, recalling the use of decoration in the handmade Bibles of earlier times.

The illustrations in this volume are from several sources. These include *The Illuminated Bible, Containing the Old and New Testaments* (New York: Harper & Brothers, 1846); *Cassell's Illustrated Family Bible from Matthew to Revelation* (London: Cassell, Petter & Calpin, 1860); *The Parables of Our Lord and Saviour Jesus Christ*, with illustrations engraved by the Dalziel brothers after drawings by John Everett Millais (London: Routledge, Warne and Routledge, 1864); *Sacred Pictures and Their Teachings* (Philadelphia: Keystone Publishing Co., 1895) and various other Bibles and Bible storybooks. The Millais/Dalziel engravings are among the most superb biblical illustrations of their era. They are represented here by figure numbers 24, 26, 29, 30, 31, 50, 57, 63, 65, 69, 72, 163, 167, 173, 174, 176, 182, 187, 190 and 231. The captions in this book are derived from the Revised Standard Version of the Bible.

CONTENTS

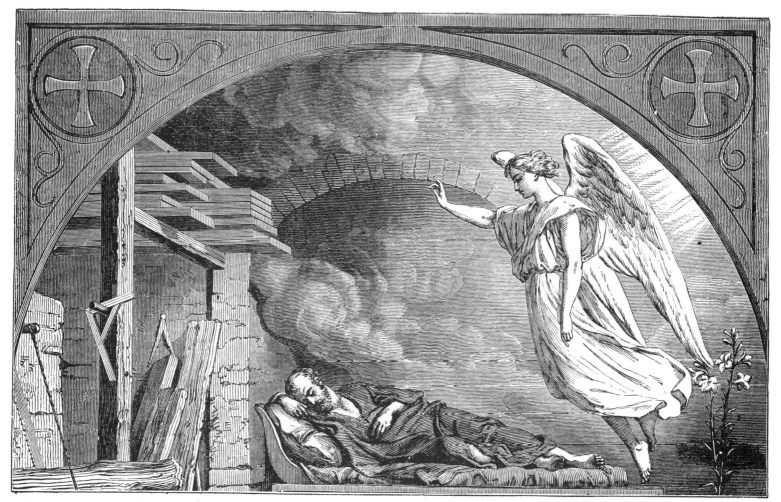

Fig. 1: The angel appearing to Joseph in a dream (1:20).

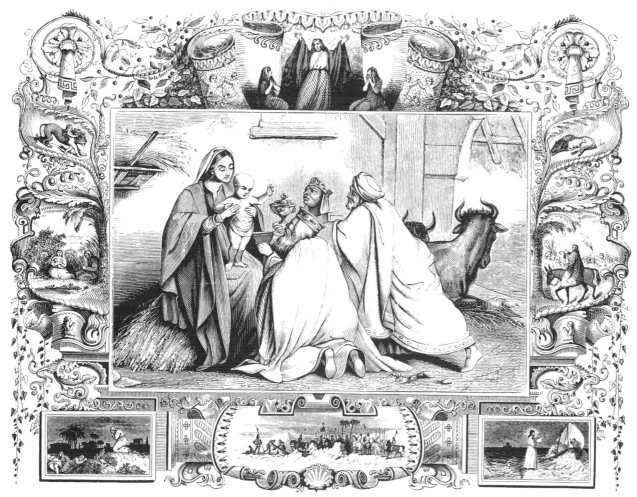

Fig. 2: Wise men from the East (2:11).

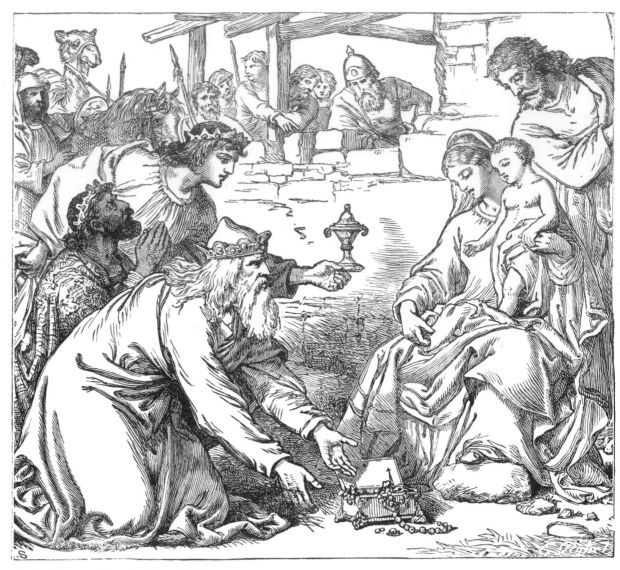

Fig. 3: Wise men from the East (2:11).

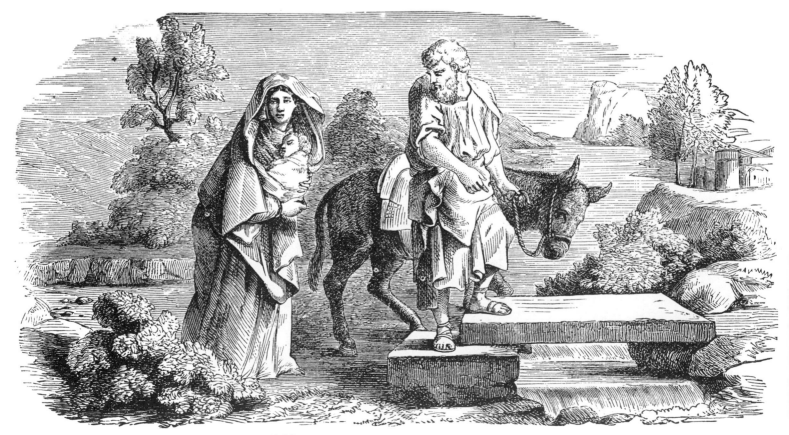

Fig. 4: The Flight into Egypt (2:14).

2 *Matthew*

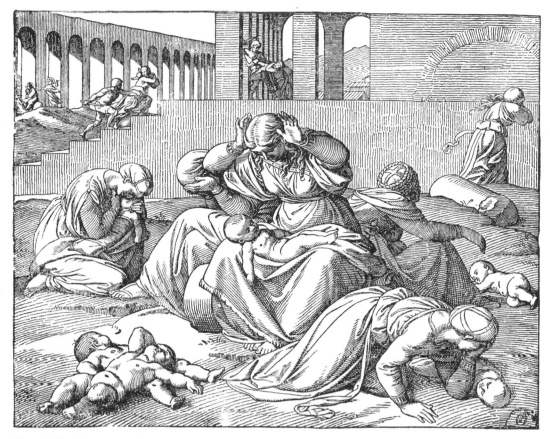

Fig. 5: The Massacre of the Innocents (2:16).

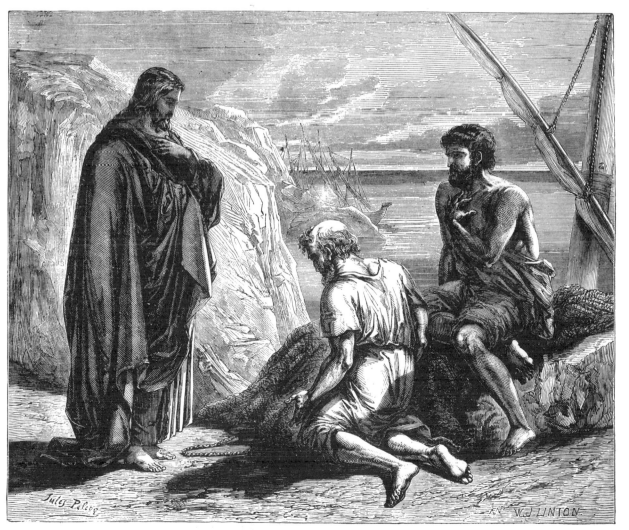

Fig. 6: The calling of Peter and Andrew (4:18–20).

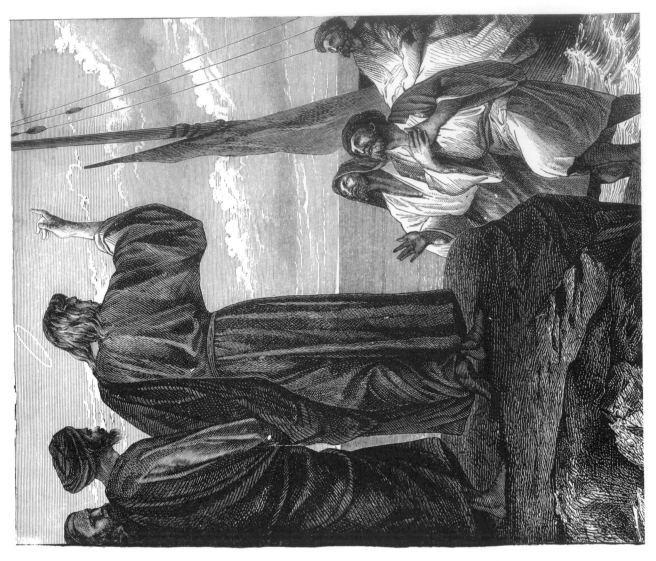

Fig. 8: The calling of James and John (4:21–22).

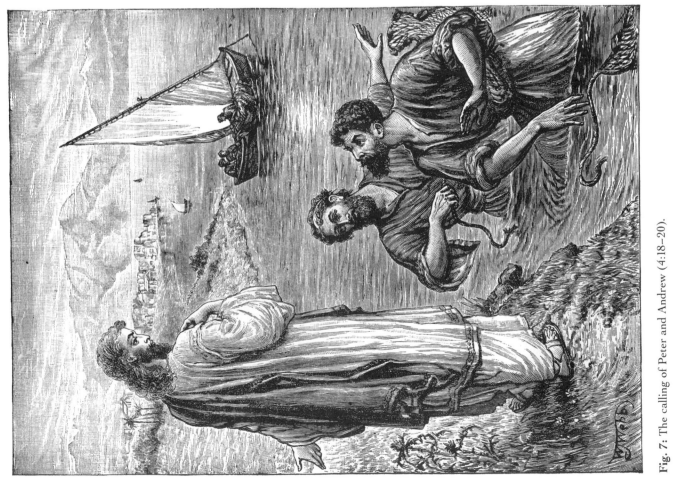

Fig. 7: The calling of Peter and Andrew (4:18–20).

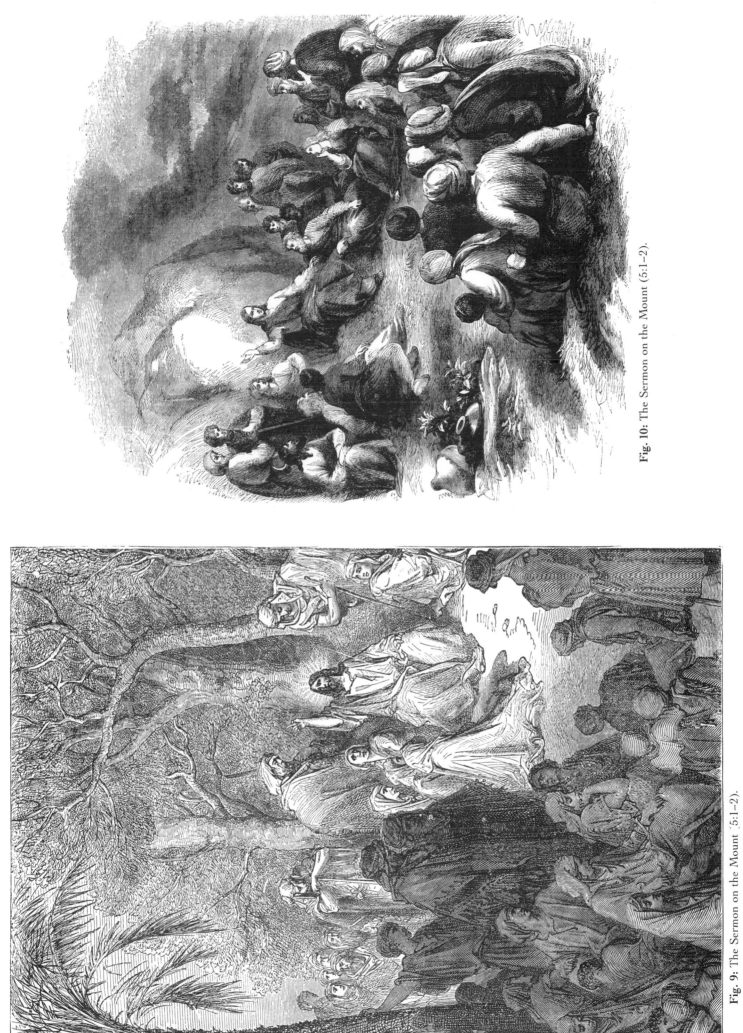

Fig. 10: The Sermon on the Mount (5:1–2).

Fig. 9: The Sermon on the Mount (5:1–2).

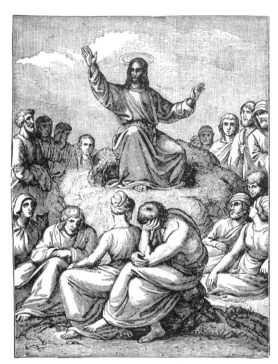

Fig. 11: The Sermon on the Mount (5:1–2).

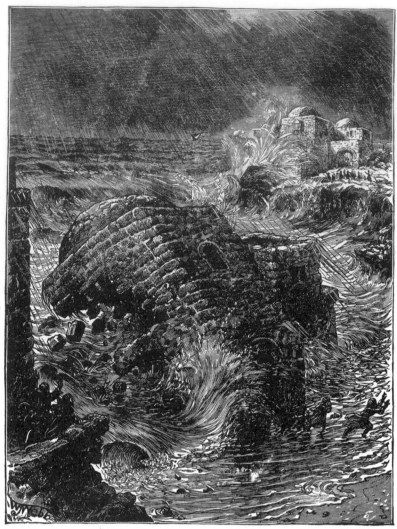

Fig. 12: The house built on sand as described in the Sermon on the Mount (7:26–27).

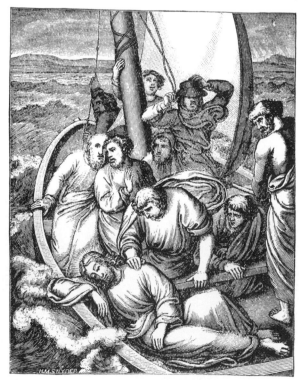

Fig. 15: Jesus asleep in the storm (8:24).

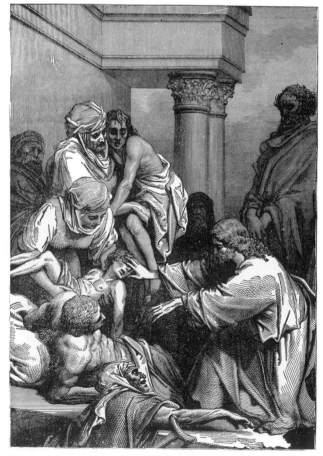

Fig. 14: Jesus healing the sick (8:16).

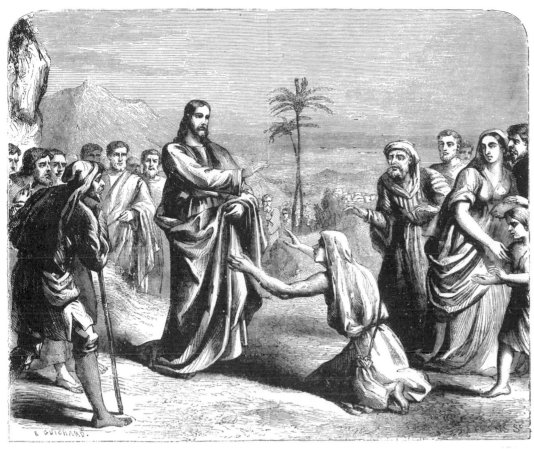

Fig. 13: Jesus cleansing a leper (8:2–3).

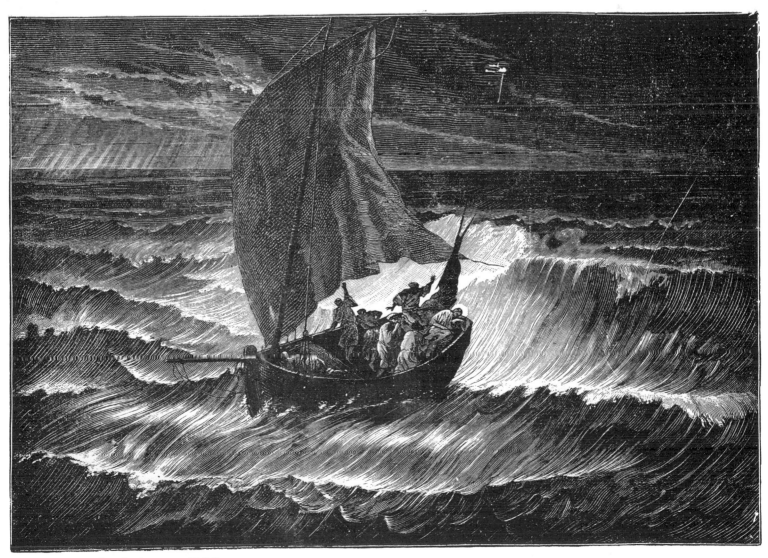

Fig. 16: Jesus asleep in the storm (8:24).

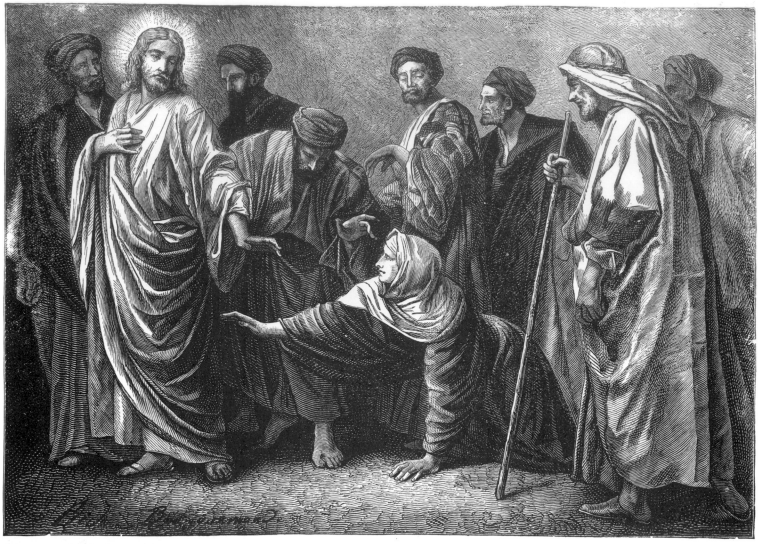

Fig. 17: "'Take heart, daughter; your faith has made you well'" (9:22).

Fig. 18: Jesus raising the ruler's daughter (9:25).

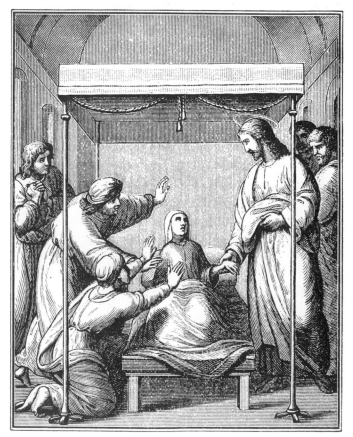

Fig. 19: Jesus raising the ruler's daughter (9:25).

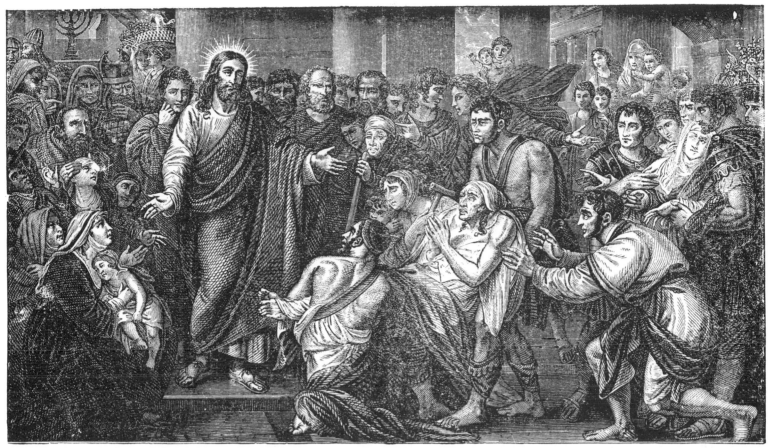

Fig. 20: Jesus preaching and healing the sick (9:35).

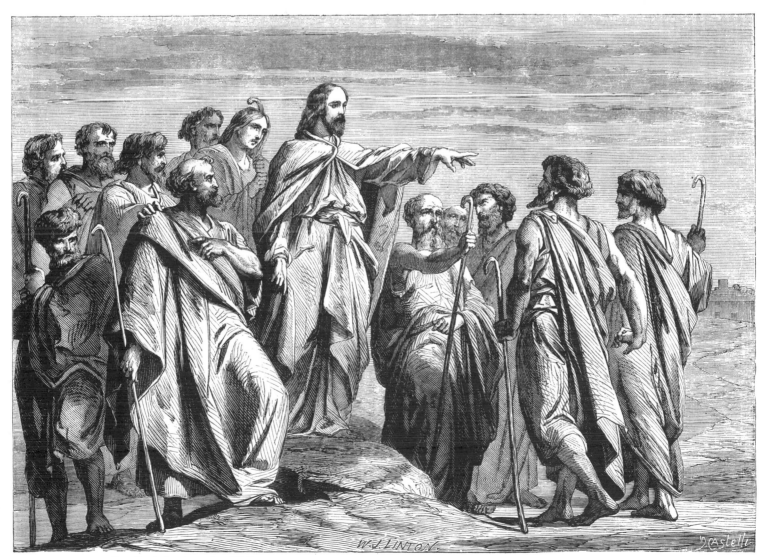

Fig. 21: Jesus sending forth the Apostles (10:1).

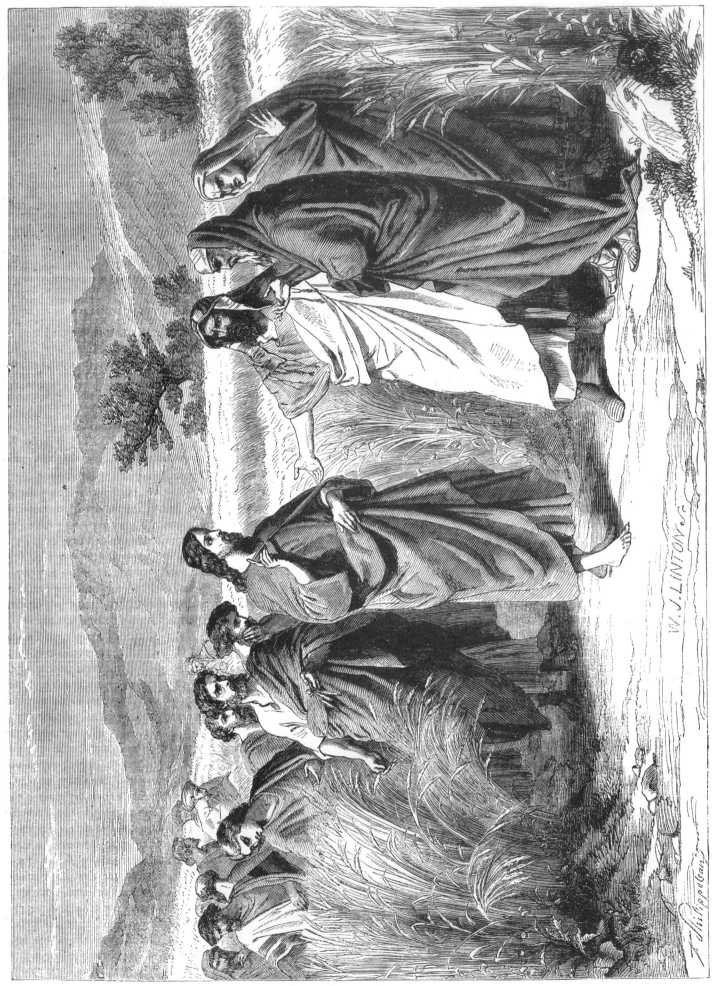

Fig. 22: The Pharisees criticizing the disciples for plucking heads of grain on the sabbath (12:1–2).

Fig. 24: The sower (13:3–23).

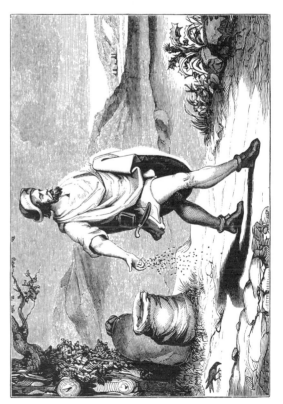

Fig. 25: The sower (13:3–23).

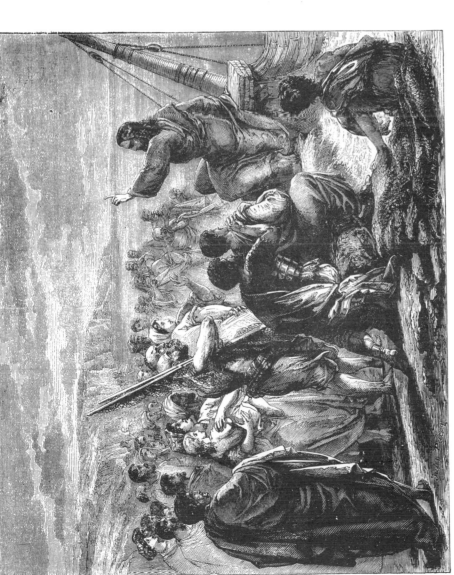

Fig. 23: Jesus teaching by the sea (13:1–3).

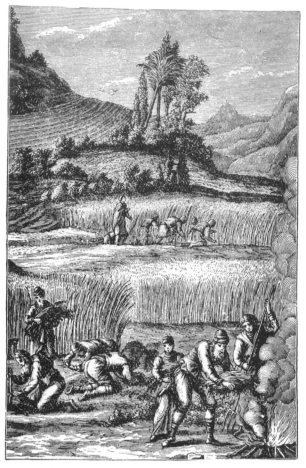

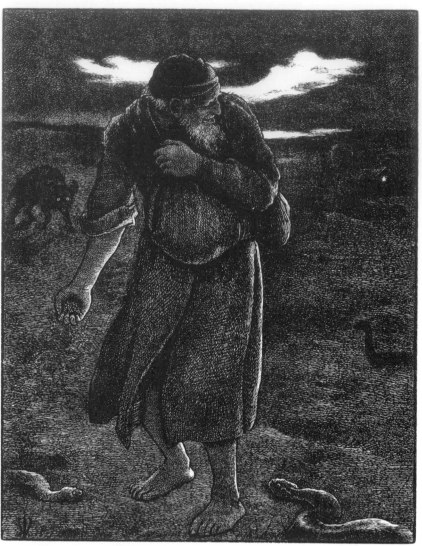

Fig. 28: The reapers burning the weeds (13:30).

Fig. 26: An enemy sowing weeds among the wheat (13:25).

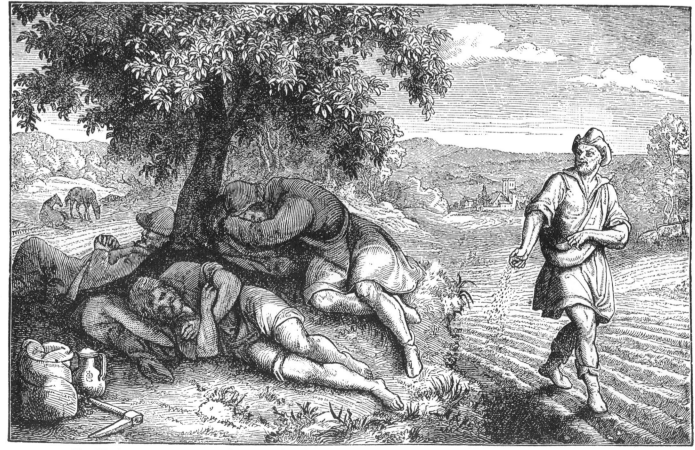

Fig. 27: An enemy sowing weeds among the wheat (13:25).

Fig. 29: The leaven (13:33).

Fig. 30: The hidden treasure (13:44).

Fig. 31: The pearl of great price (13:45–46).

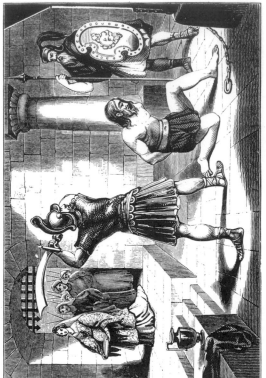

Fig. 33: The beheading of John the Baptist (14:10).

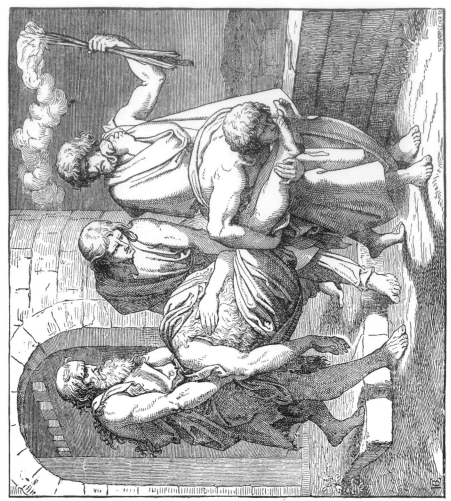

Fig. 34: The burial of John the Baptist (14:12).

Fig. 32: The pearl of great price (13:45–46).

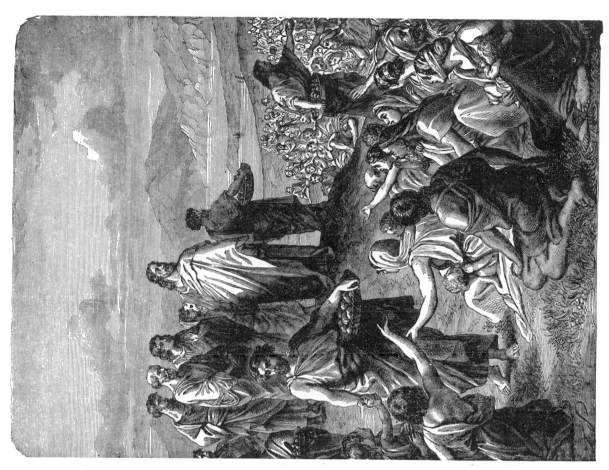

Fig. 37: The multiplication of loaves and fishes (14:19).

Fig. 36: The multiplication of loaves and fishes (14:19).

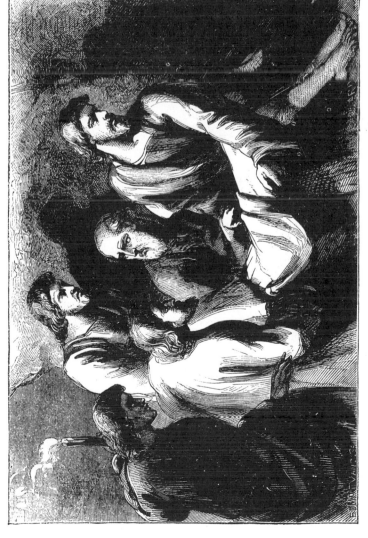

Fig. 35: The burial of John the Baptist (14:12).

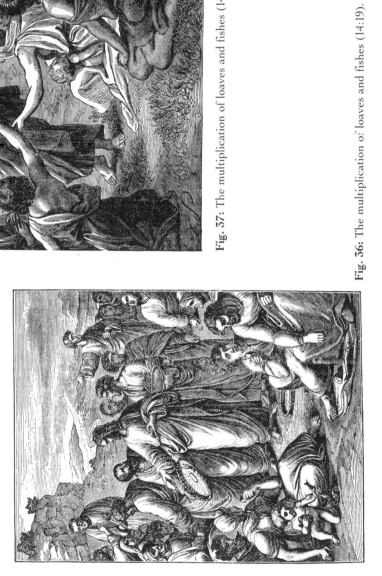

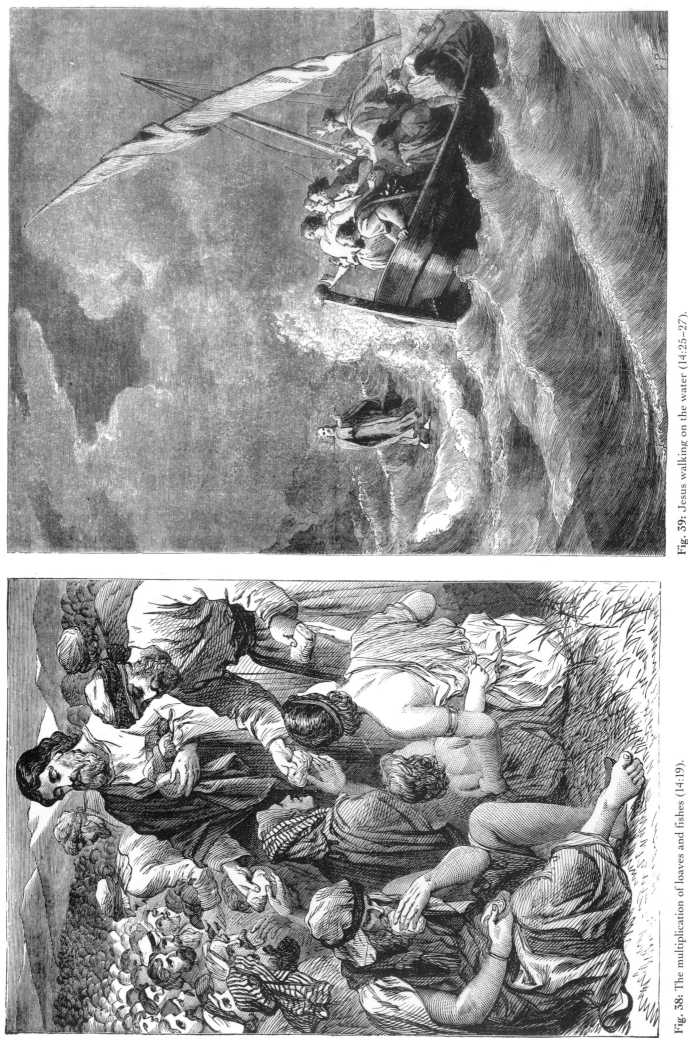

Fig. 39: Jesus walking on the water (14:25–27).

Fig. 38: The multiplication of loaves and fishes (14:19).

Fig. 42: Jesus healing the sick (14:35–36).

Fig. 41: Jesus saving Peter (14:30–31).

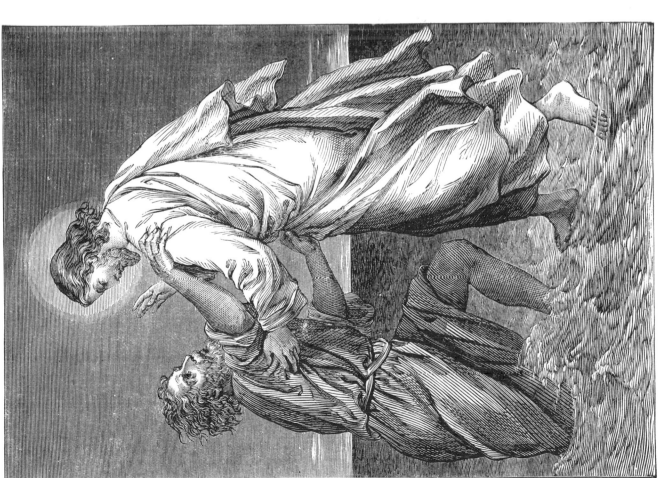

Fig. 40: Jesus saving Peter (14:3C–31).

Fig. 43: The multiplication of loaves and fishes (15:36).

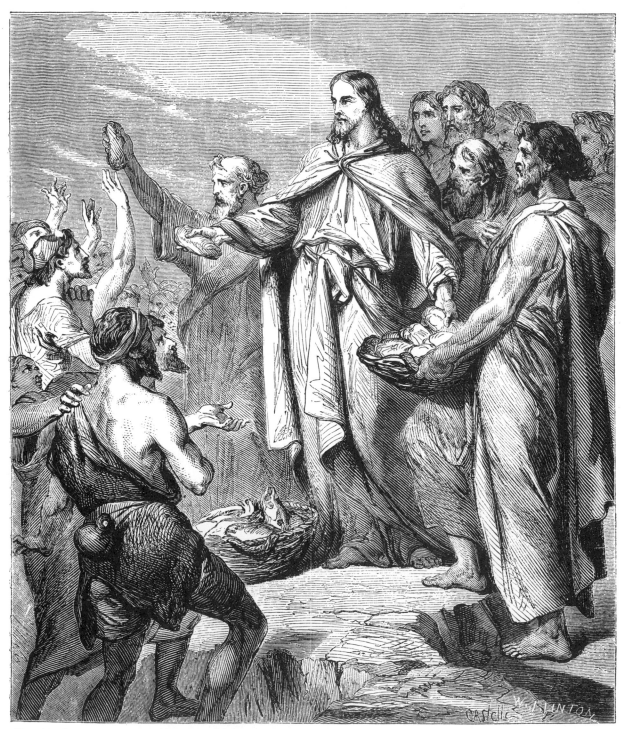

Fig. 44: The multiplication of loaves and fishes (15:36).

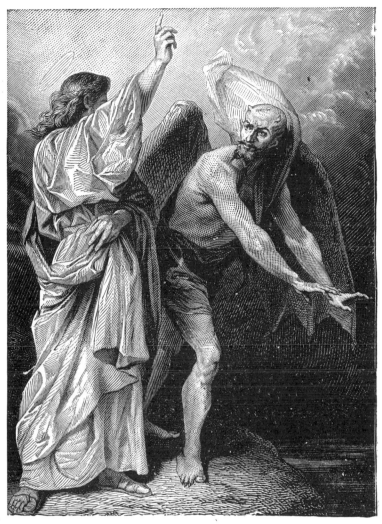

Fig. 45: Jesus said to Peter, "'Get behind me, Satan!'" (16:23).

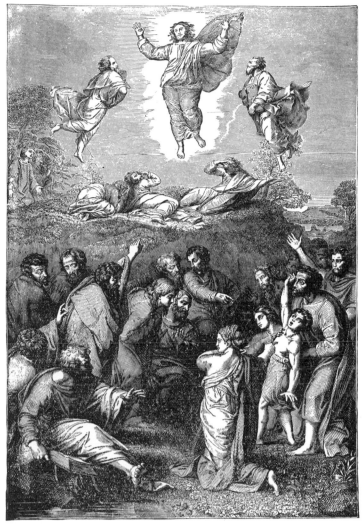

Fig. 46: The Transfiguration of Jesus and the appearance of Moses and Elijah witnessed by Peter, James and John (17:1–6).

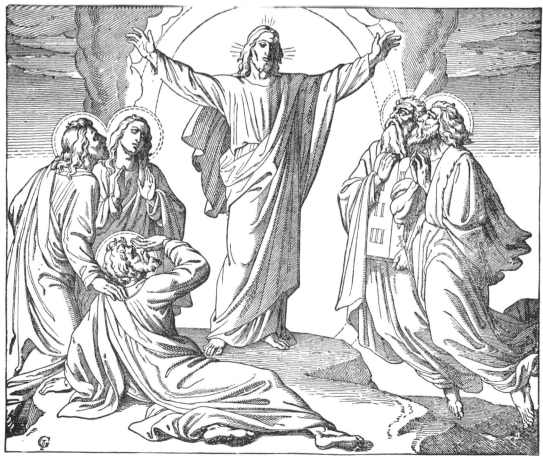

Fig. 47: The Transfiguration of Jesus and the appearance of Moses and Elijah witnessed by Peter, James and John (17:1–6).

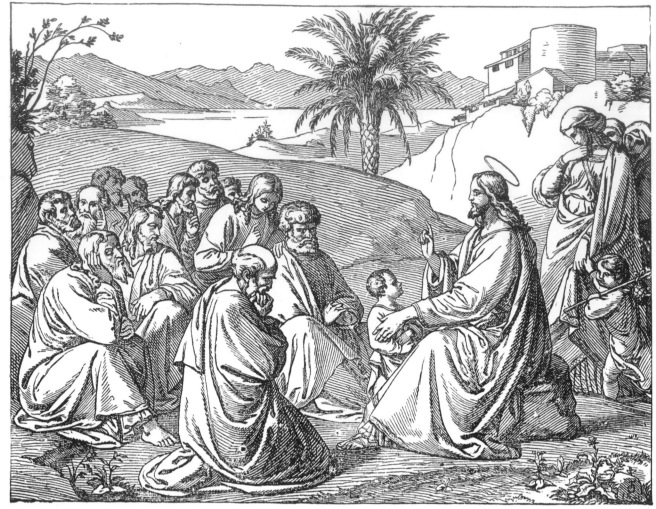

Fig. 48: Jesus teaching humility through a child (18:2–4).

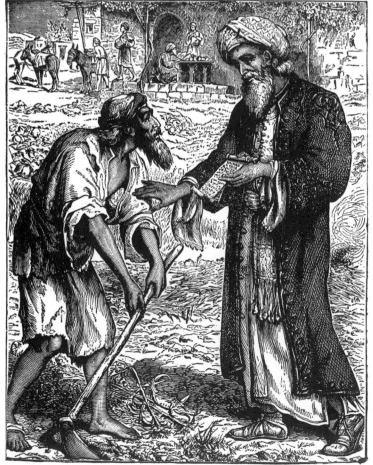

Fig. 49: The king requesting payment from the unmerciful servant (18:23).

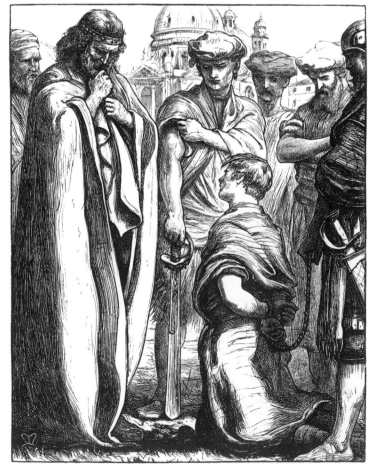

Fig. 50: The unmerciful servant pleading with the king (18:25–26).

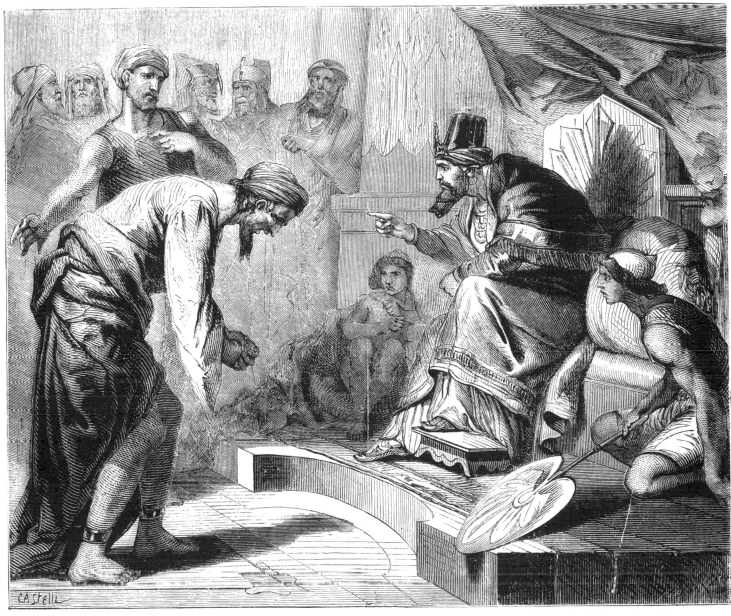

Fig. 52: "'"Should not you have had mercy on your fellow servant, as I had mercy on you?"'" (18:33).

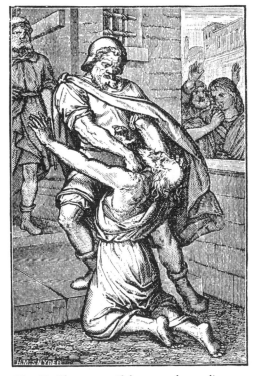

Fig. 51: The unmerciful servant demanding payment from his fellow servant (18:28–29).

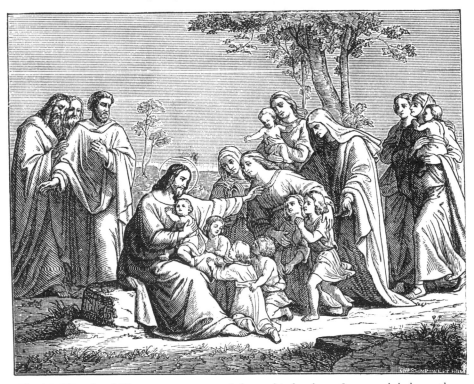

Fig. 53: "'Let the children come to me, and do not hinder them; for to such belongs the kingdom of heaven'" (19:14).

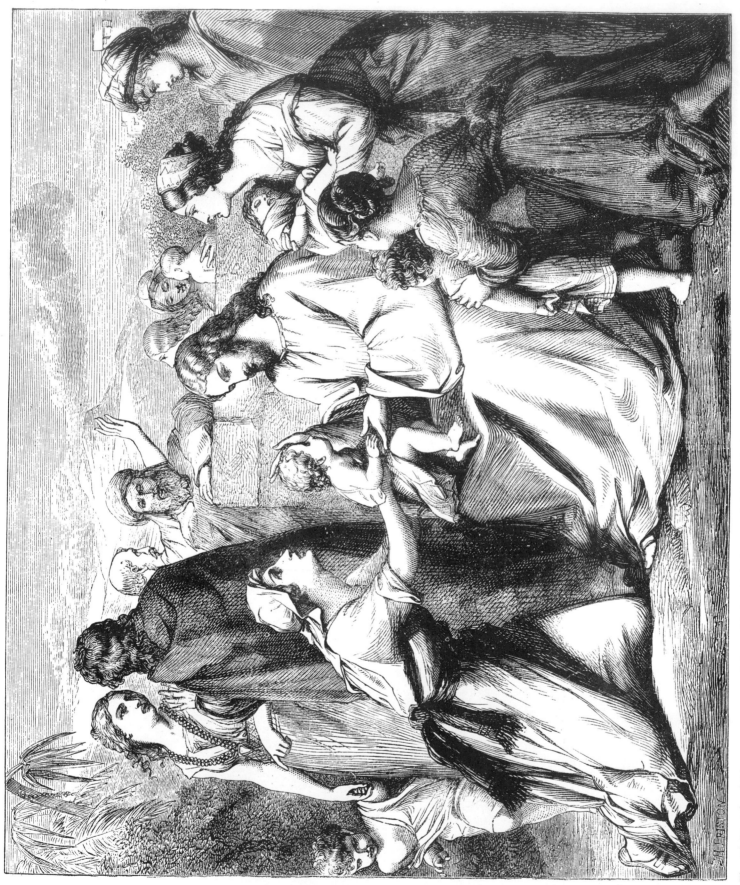

Fig. 54: "'Let the children come to me, and do not hinder them; for to such belongs the kingdom of heaven'" (19:14).

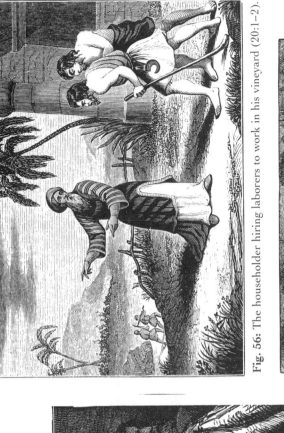

Fig. 56: The householder hiring laborers to work in his vineyard (20:1–2).

Fig. 57: The laborers contesting their wages (20:11–12).

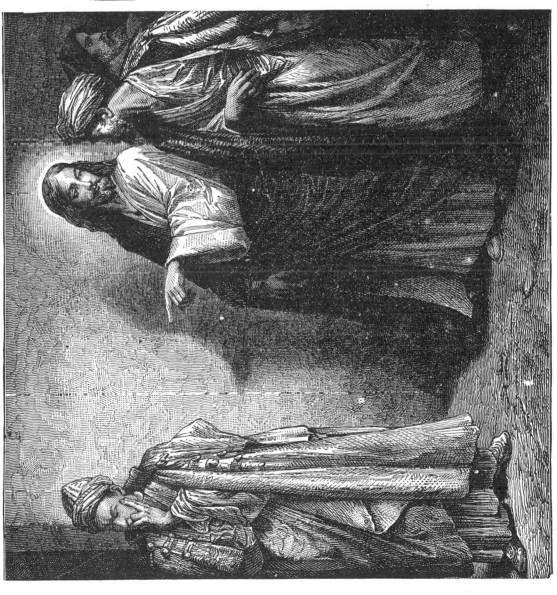

Fig. 55: Jesus and the rich young man (19:21–22).

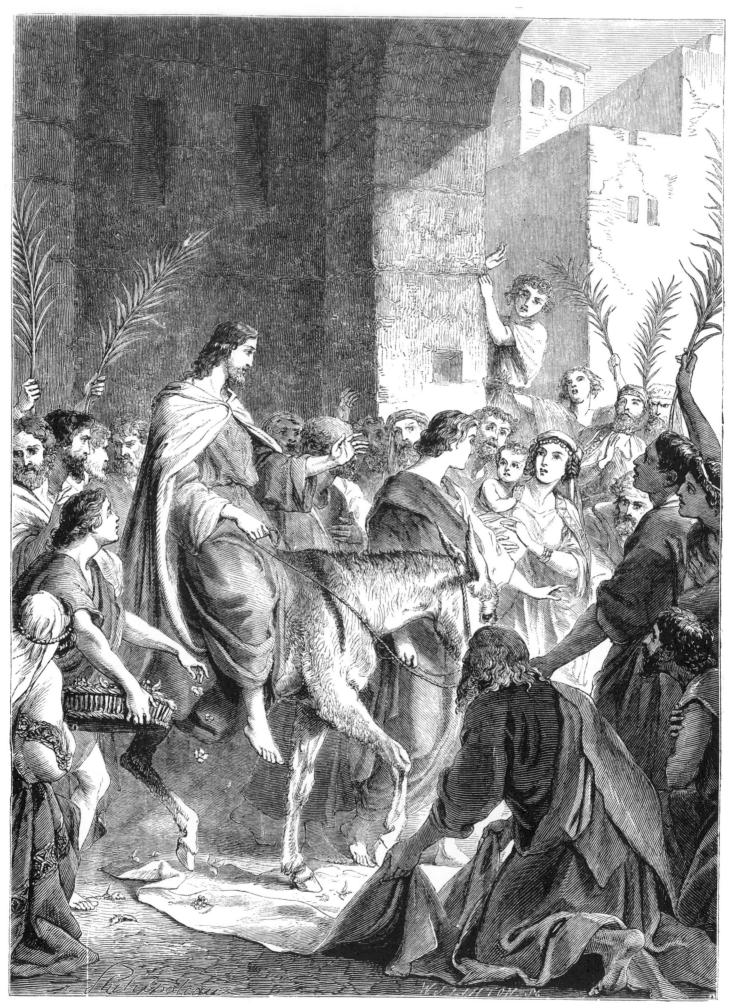

Fig. 58: The Entry into Jerusalem (21:7–9).

Fig. 59: The Entry into Jerusalem (21:7–9).

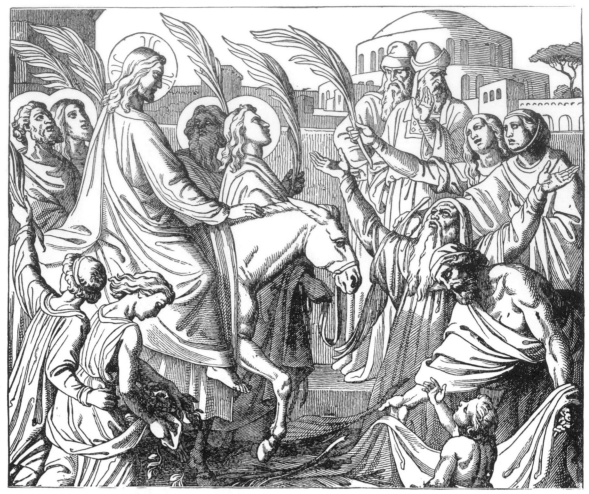

Fig. 60: The Entry into Jerusalem (21:7–9).

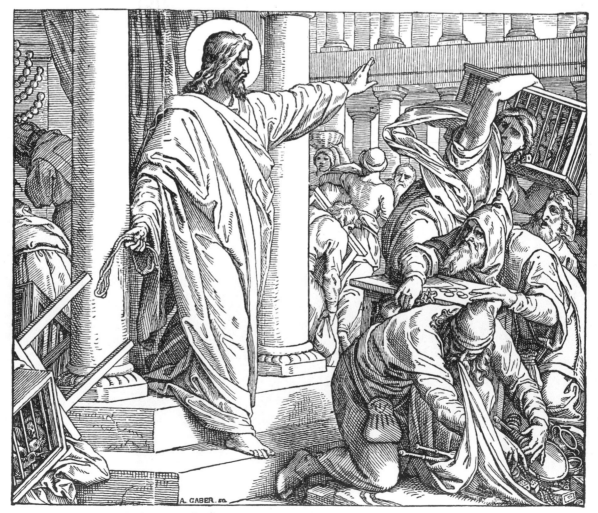

Fig. 61: Jesus driving the buyers and sellers out of the temple (21:12–13).

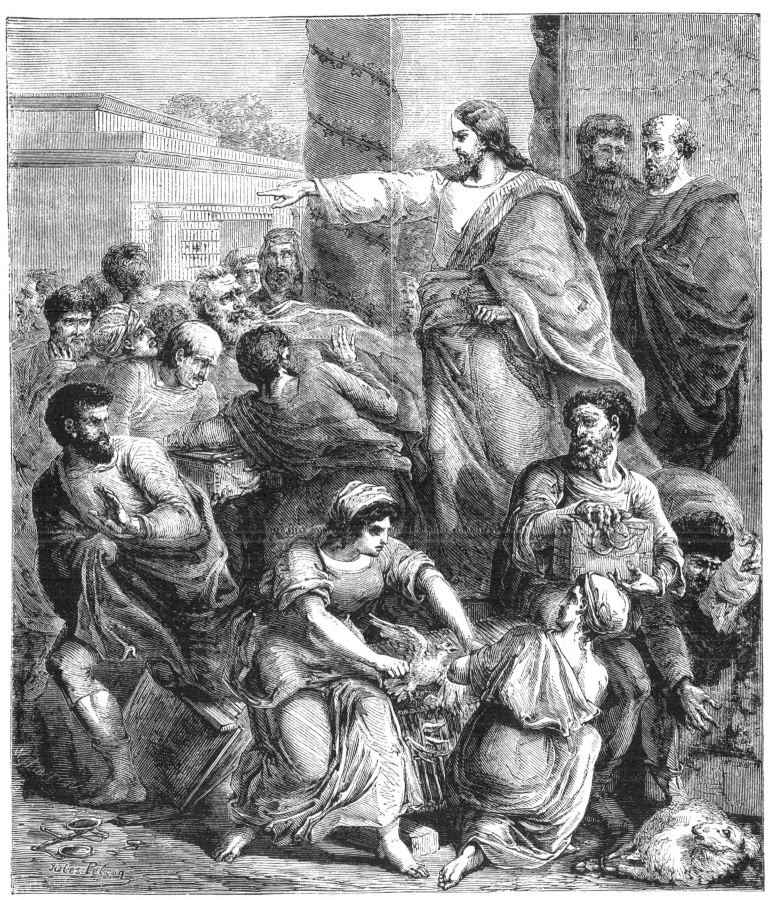

Fig. 62: Jesus driving the buyers and sellers out of the temple (21:12–13).

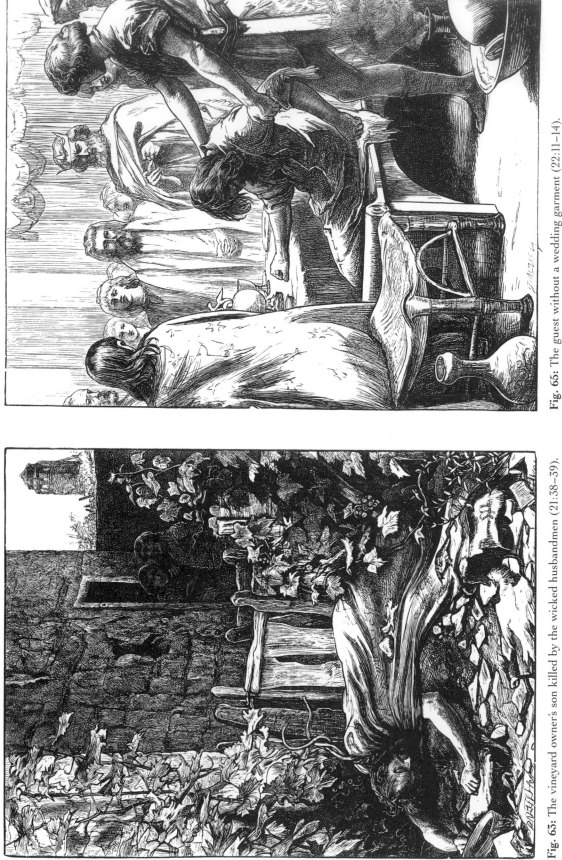

Fig. 65: The guest without a wedding garment (22:11–14).

Fig. 63: The vineyard owner's son killed by the wicked husbandmen (21:38–39).

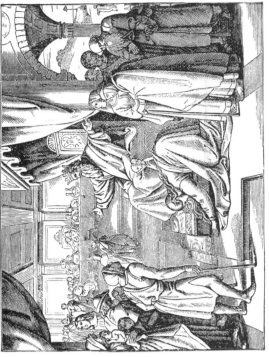

Fig. 64: The wedding hall (22:10).

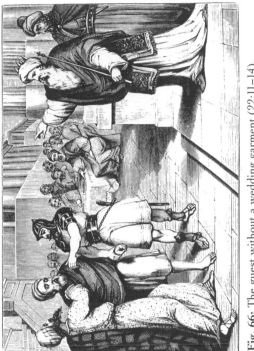

Fig. 66: The guest without a wedding garment (22:11–14).

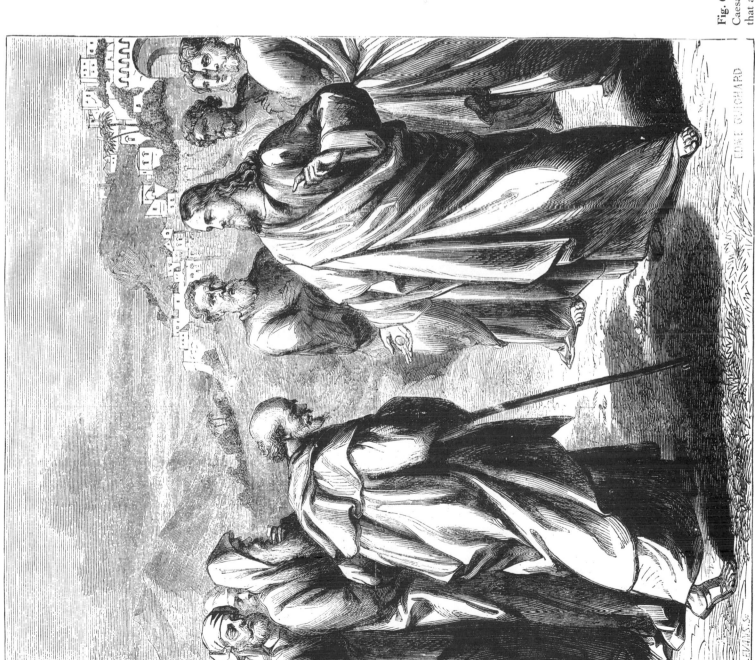

Fig. 67: Jesus said to the Pharisees, "'Render therefore to Caesar the things that are Caesar's, and to God the things that are God's'" (22:21).

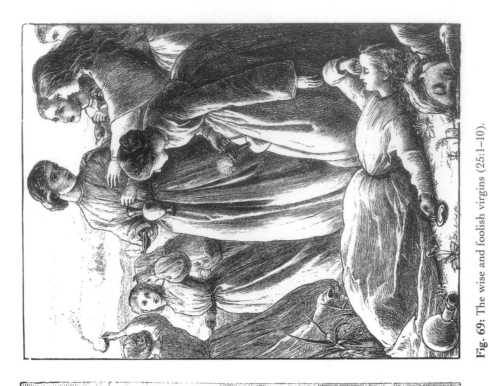

Fig. 69: The wise and foolish virgins (25:1–10).

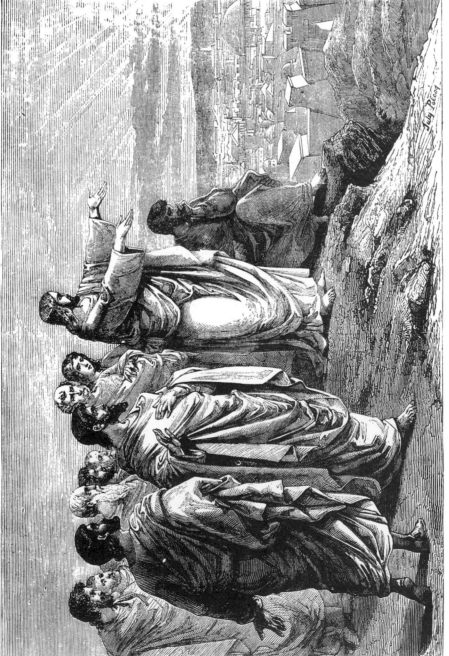

Fig. 68: Jesus weeping over Jerusalem (23:37–39).

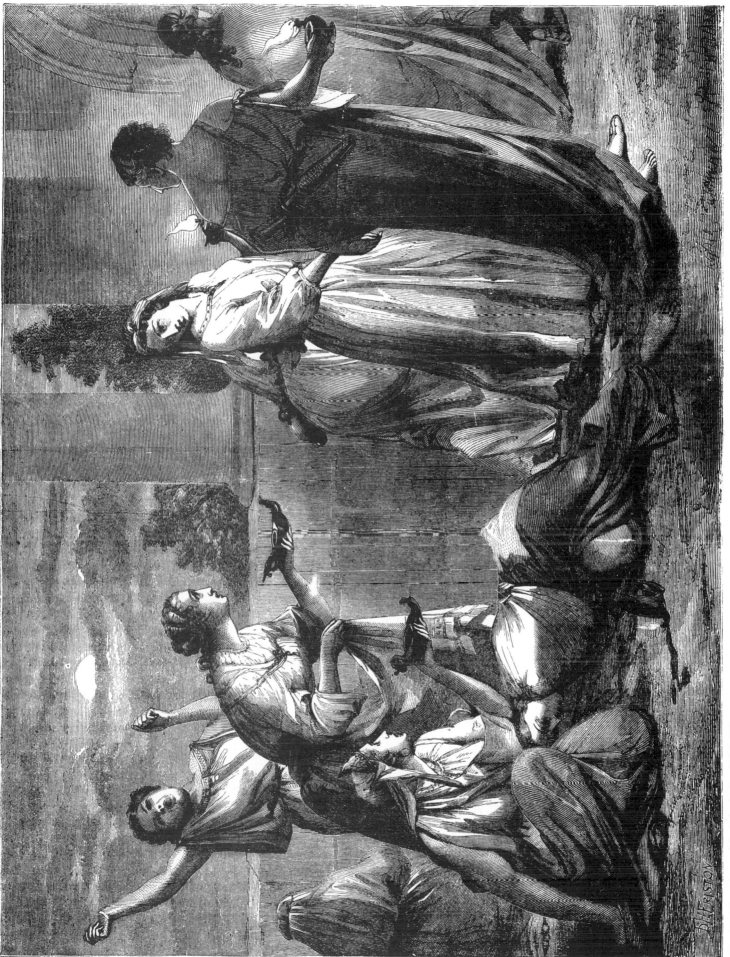

Fig. 70: The wise and foolish virgins (25:1–10).

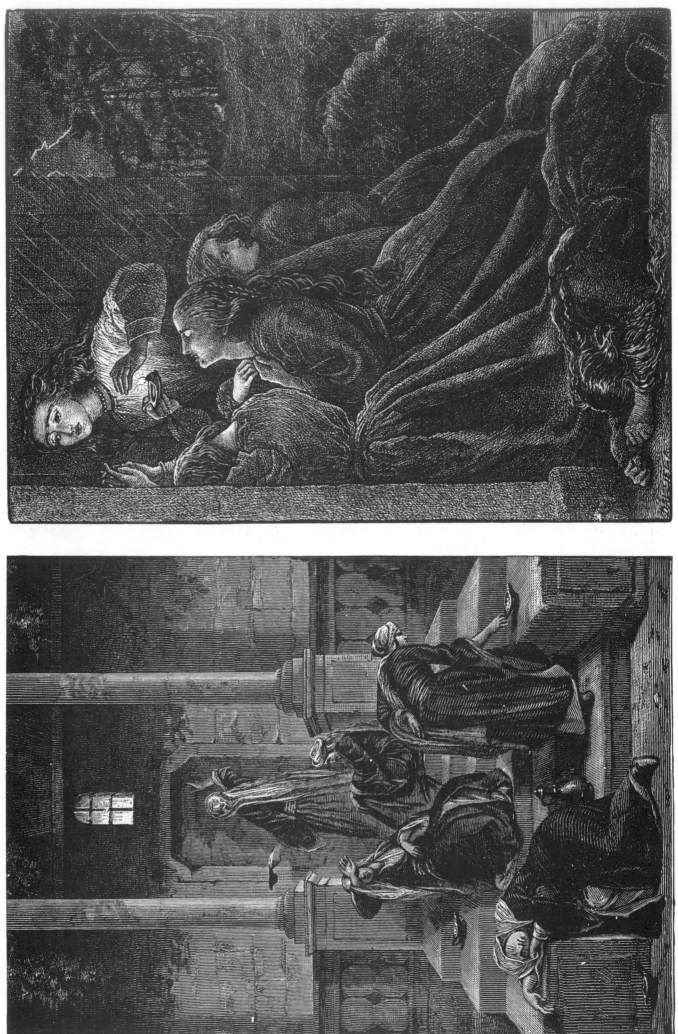

Fig. 71: The foolish virgins (25:11–13).

Fig. 72: The foolish virgins (25:11–13).

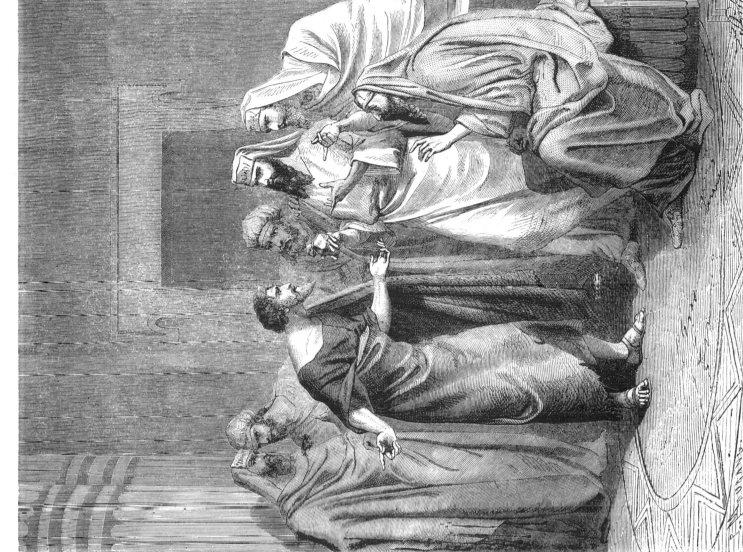

Fig. 75: Judas receiving payment from the chief priests (26:14–15).

Fig. 74: The talents (25:14–30).

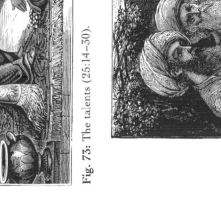

Fig. 73: The talents (25:14–30).

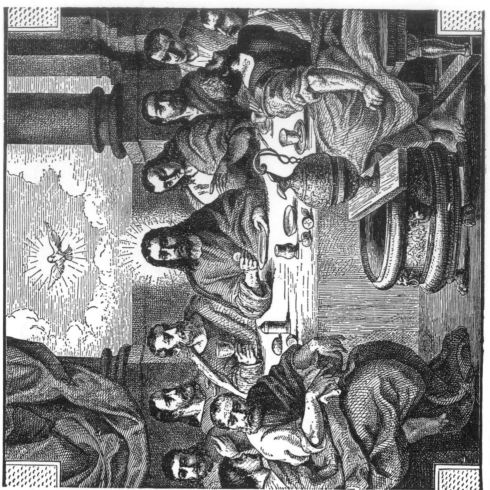

Fig. 77: The Last Supper (26:26–29).

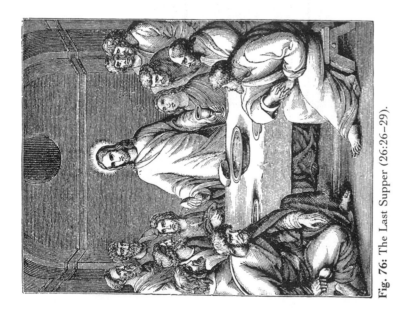

Fig. 76: The Last Supper (26:26–29).

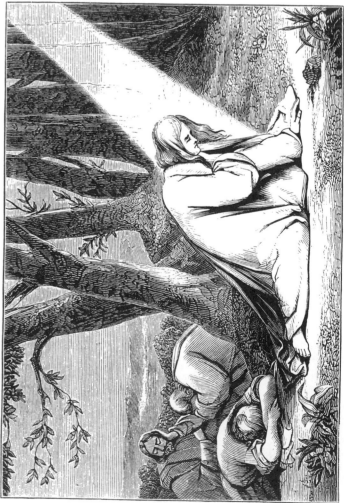

Fig. 78: The Agony in the Garden (26:36–46).

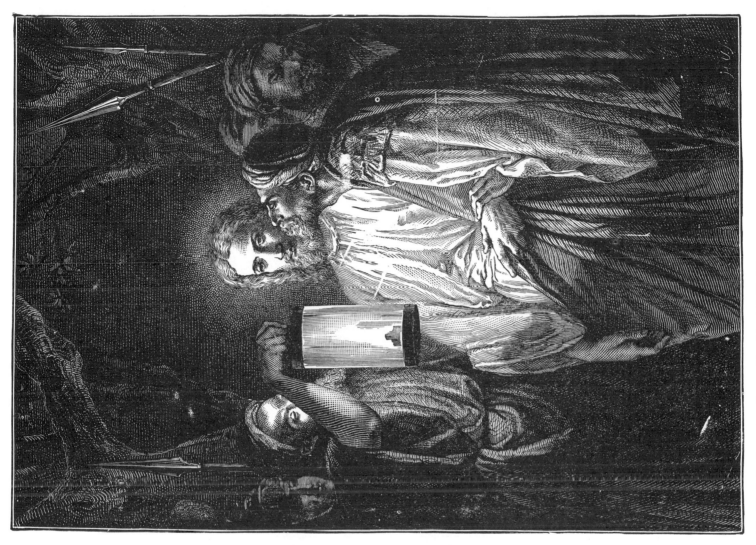

Fig. 80: Judas betraying Jesus with a kiss (26:48–50).

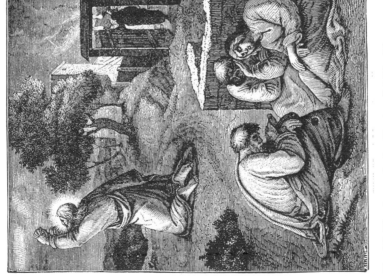

Fig. 79: The Agony in the Garden (26:36–46).

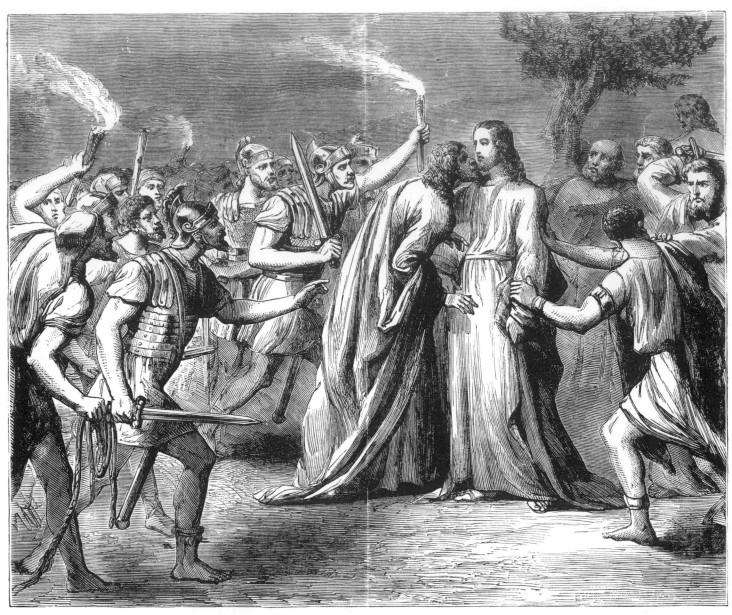

Fig. 81: Judas betraying Jesus with a kiss (26:48–50).

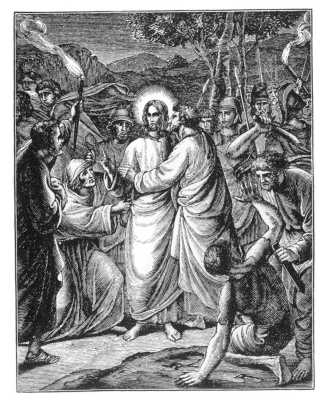

Fig. 82: Judas betraying Jesus with a kiss (26:48–50).

Fig. 83: Judas hanging himself (27:5).

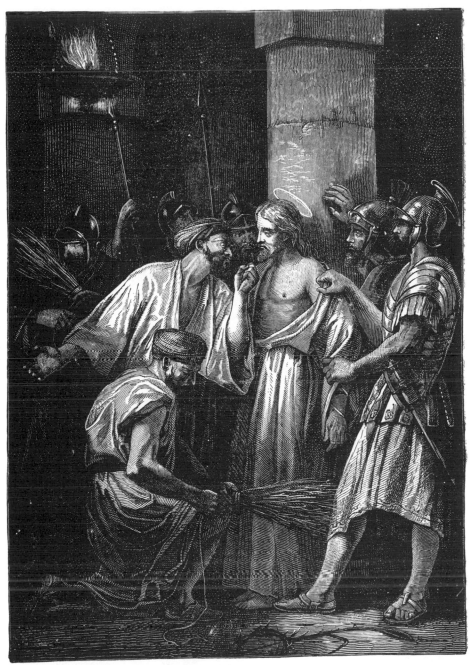

Fig. 84: The Crowning with Thorns (27:27–31).

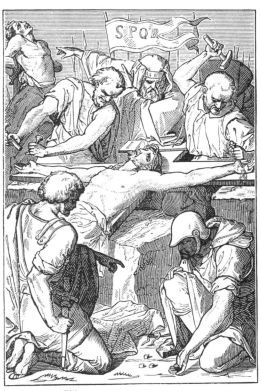

Fig. 86: "And over his head they put the charge against him, which read, 'This is Jesus the King of the Jews'" (27:37).

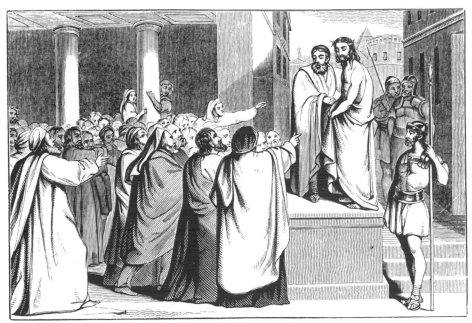

Fig. 85: The Crowning with Thorns (27:27–31).

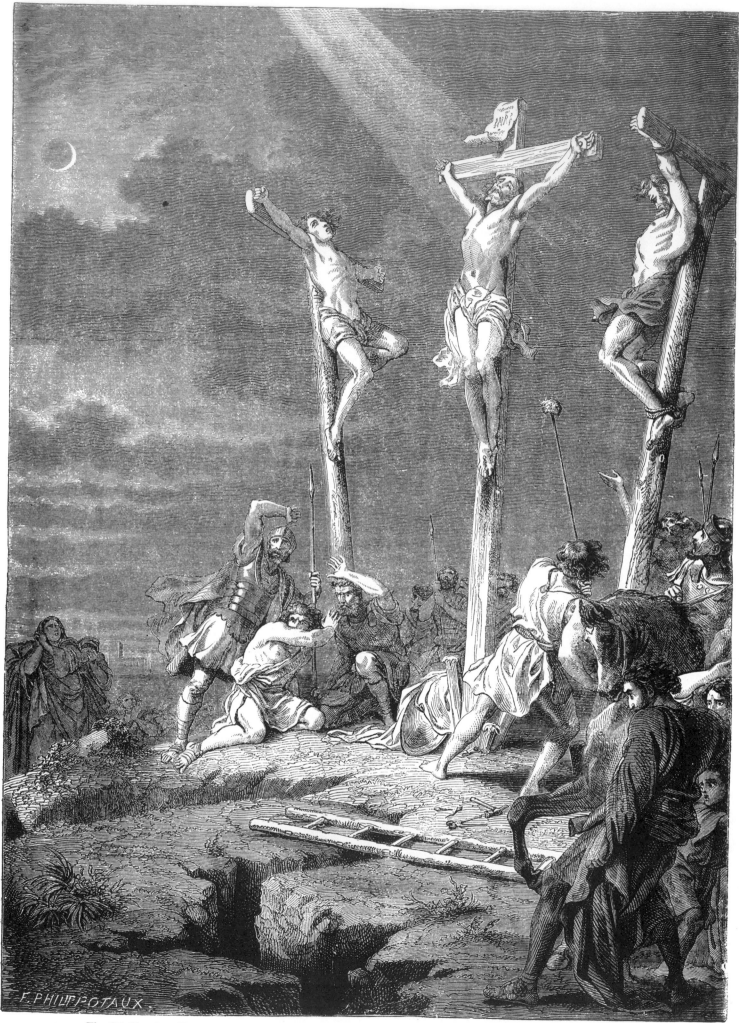

Fig. 87: The Crucifixion (27:38–50).

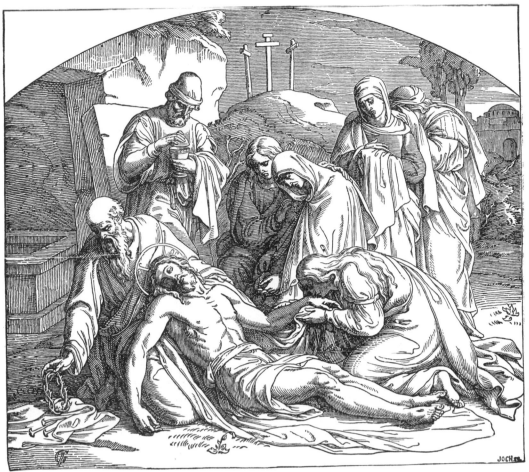

Fig. 88: The Entombment of Jesus by Joseph of Arimathea (27:59–61).

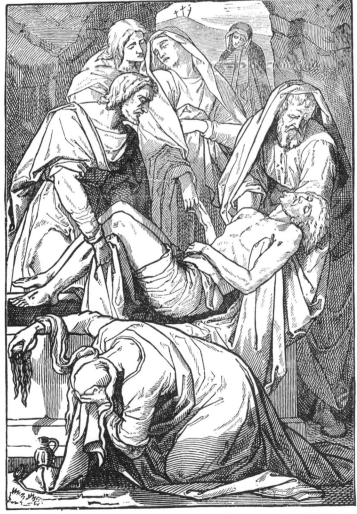

Fig. 89: The Entombment of Jesus by Joseph of Arimathea (27:59–61).

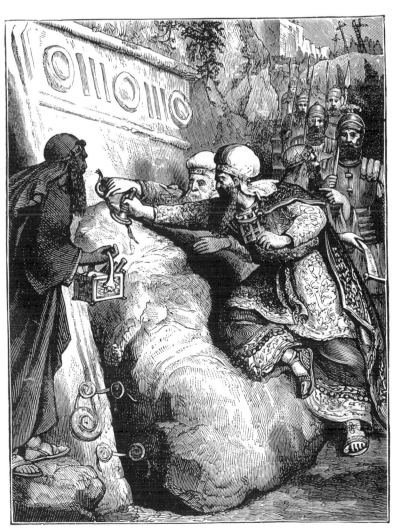

Fig. 90: Sealing the sepulchre (27:66).

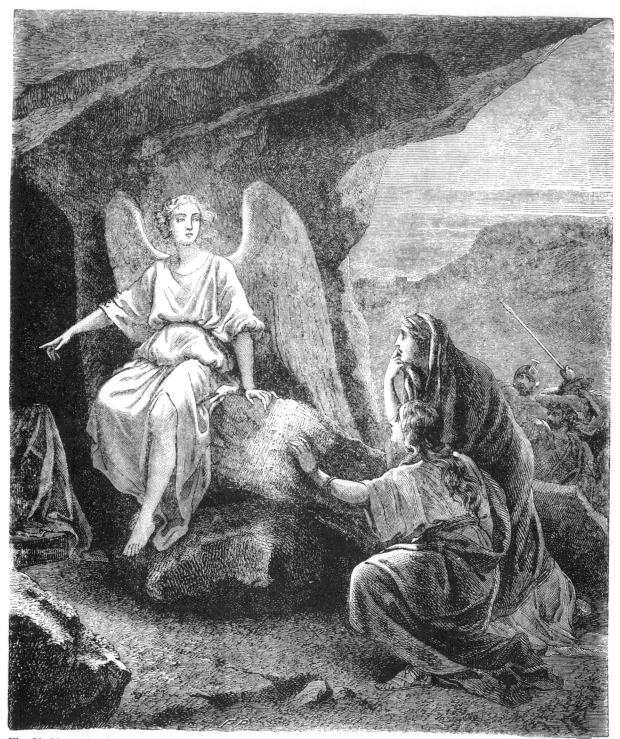

Fig. 91: Mary Magdalene and Mary the mother of James at the empty tomb (28:1–7).

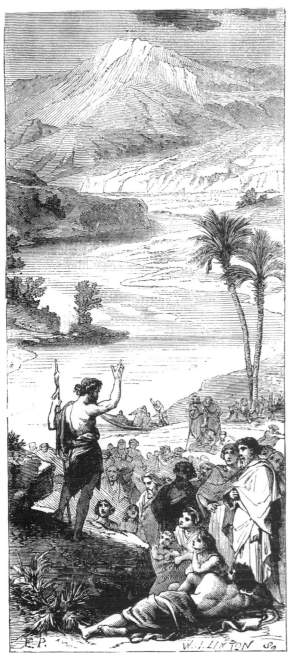

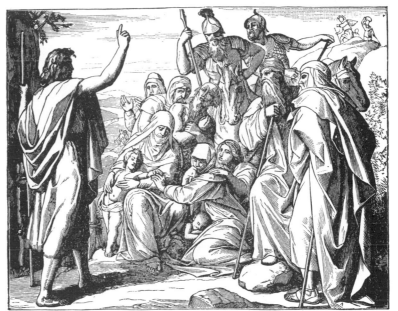

Fig. 93: John the Baptist preaching in the wilderness (1:4).

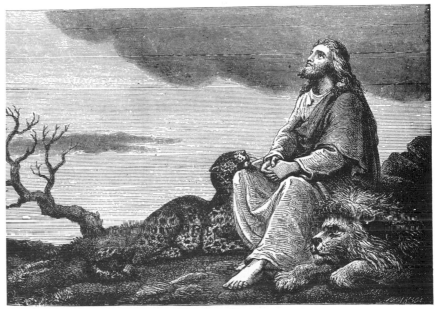

Fig. 92: John the Baptist preaching in the wilderness (1:4).

Fig. 94: Jesus in the wilderness with the wild beasts (1:13).

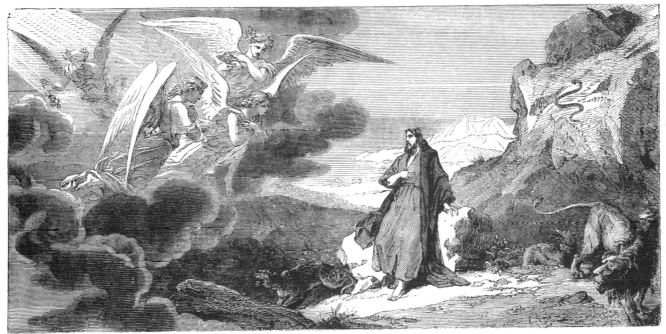

Fig. 95: Jesus in the wilderness with the wild beasts (1:13).

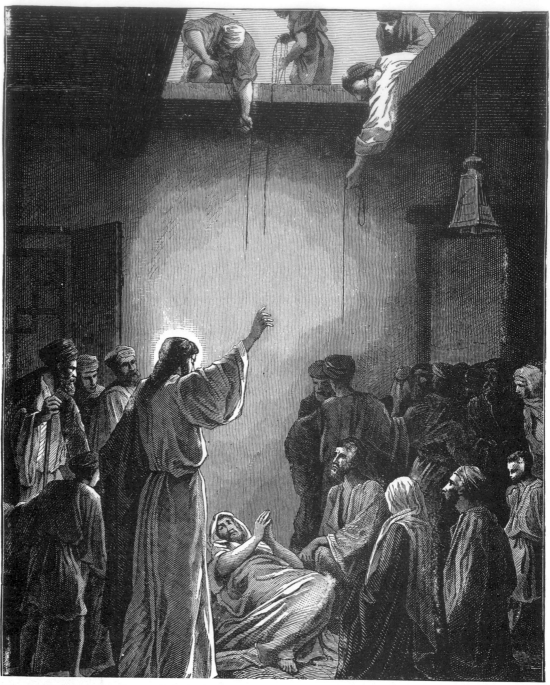

Fig. 96: Jesus healing the paralytic (2:4–5).

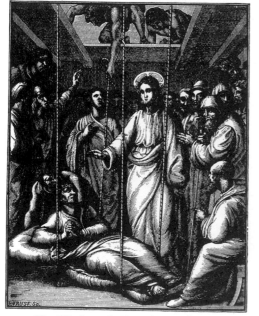

Fig. 97: Jesus healing the paralytic (2:4–5).

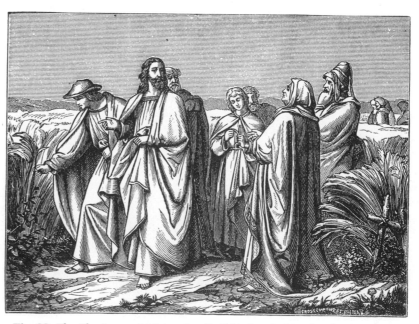

Fig. 98: The Pharisees criticizing the disciples for plucking heads of grain on the sabbath (2:23–24).

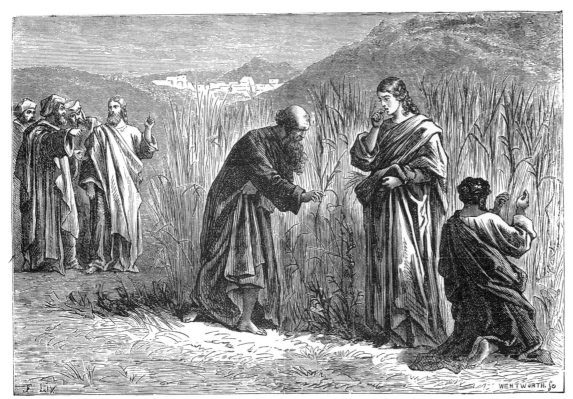

Fig. 99: The Pharisees criticizing the disciples for plucking heads of grain on the sabbath (2:23–24).

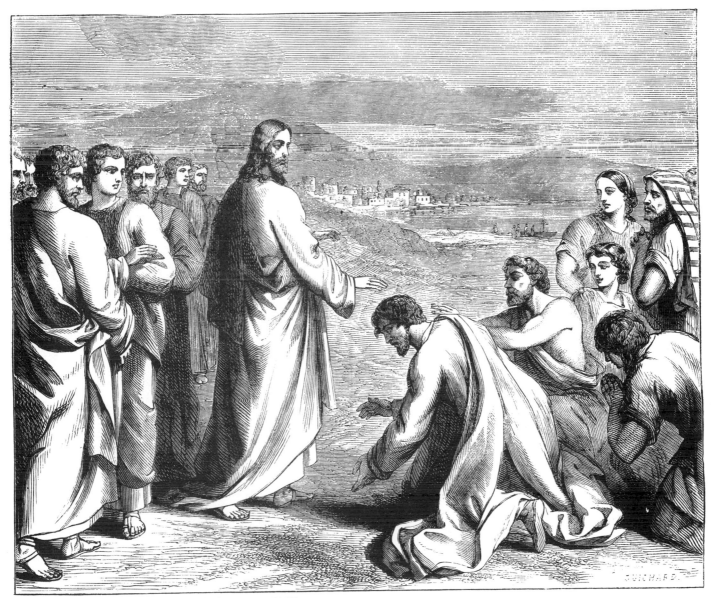

Fig. 100: Unclean spirits falling down before Jesus (3:11).

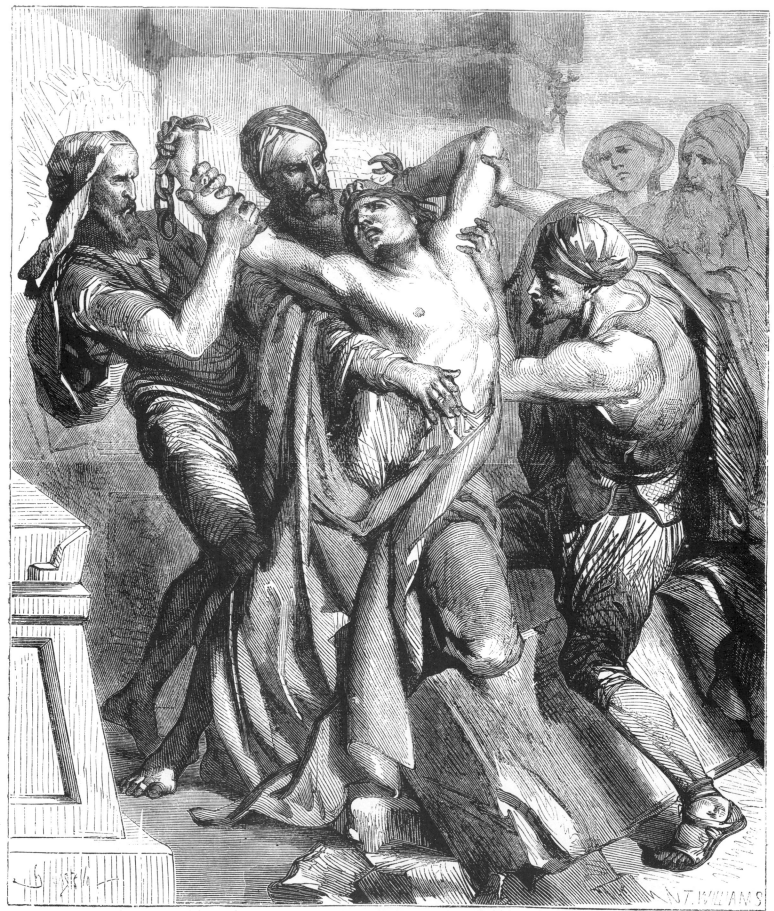

Fig. 102: The man with an unclean spirit breaking his chains (5:2–4).

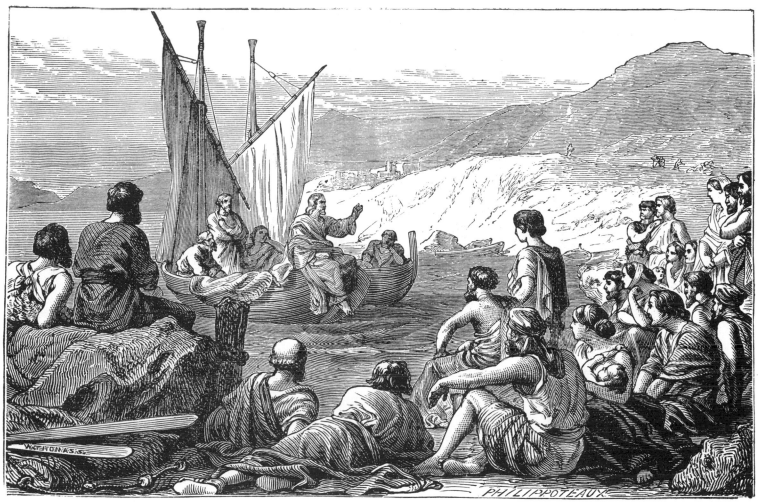

Fig. 101: Jesus teaching by the sea (4:1).

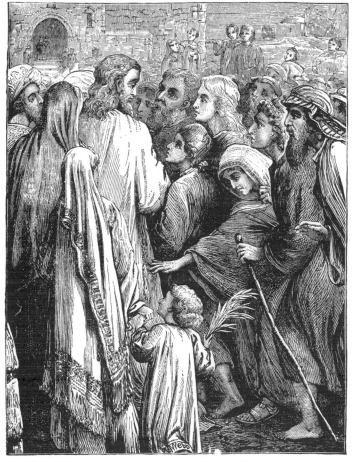

Fig. 104: "'Who touched my garments?'" (5:30).

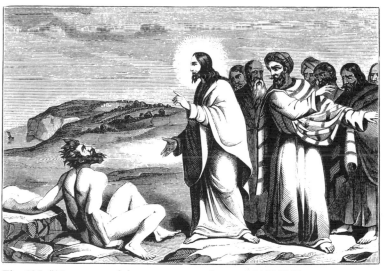

Fig. 103: "'Come out of the man, you unclean spirit!'" (5:8).

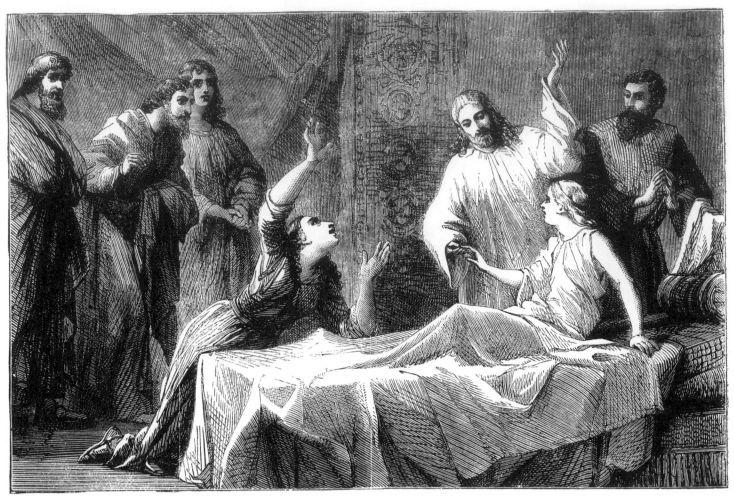

Fig. 105: Jesus raising the daughter of the ruler Jairus (5:41–42).

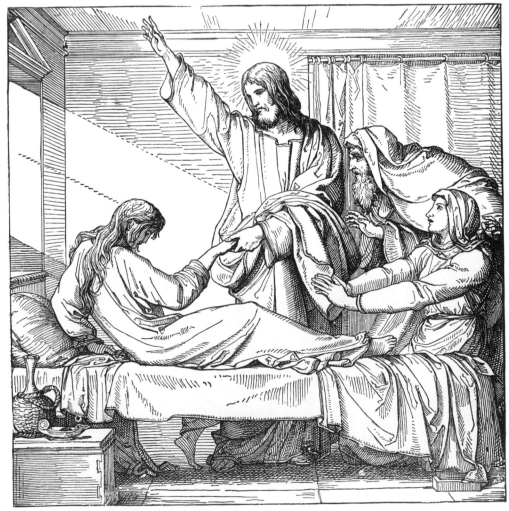

Fig. 106: Jesus raising the daughter of the ruler Jairus (5:41–42).

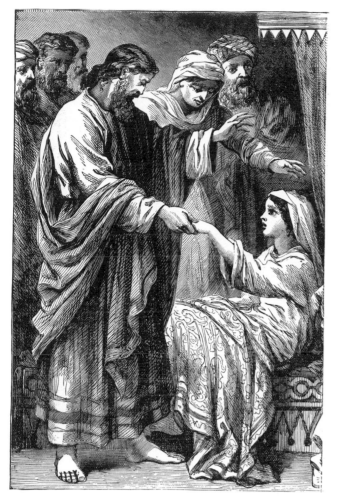

Fig. 107: Jesus raising the daughter of the ruler Jairus (5:41–42).

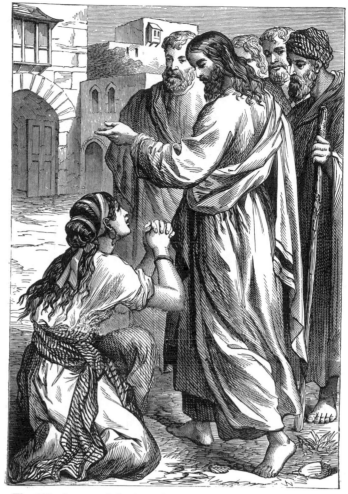

Fig. 109: Jesus and the Syrophoenician woman (7:25–26).

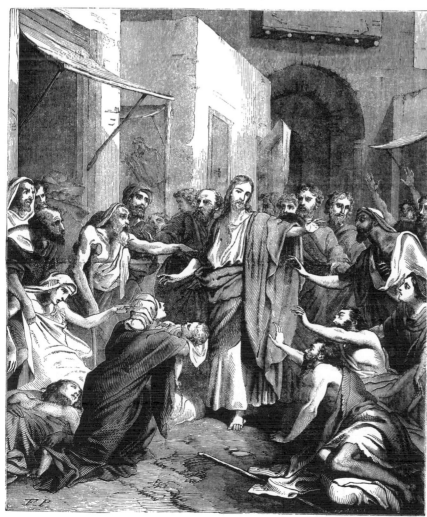

Fig. 108: Jesus healing the sick in the streets (6:56).

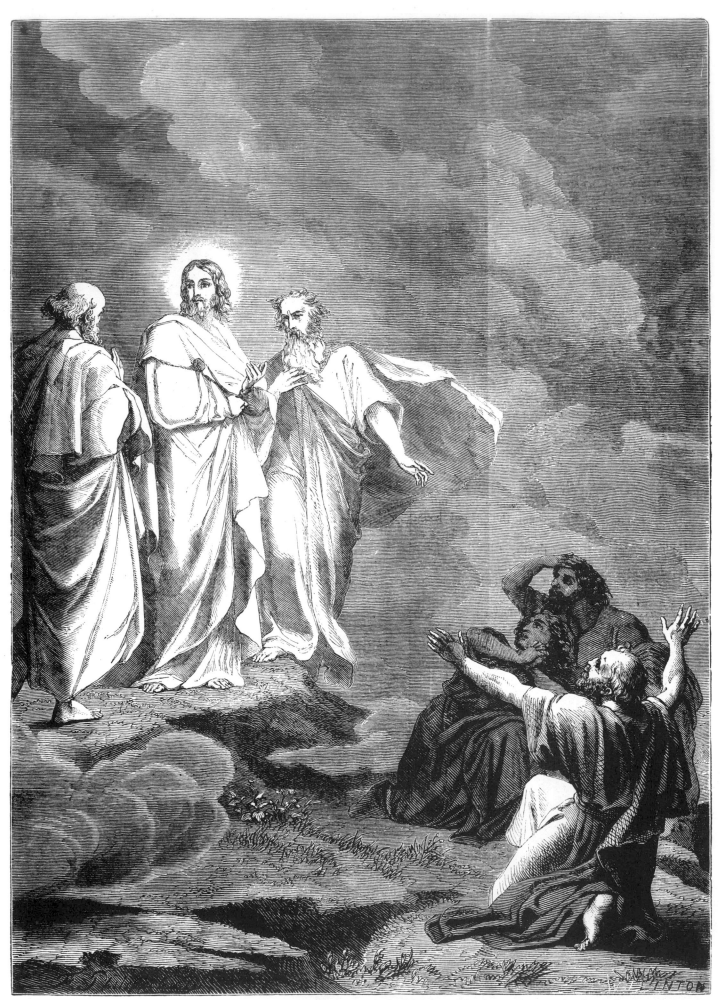

Fig. 110: The Transfiguration of Jesus and the appearance of Moses and Elijah witnessed by Peter, James and John (9:2–4).

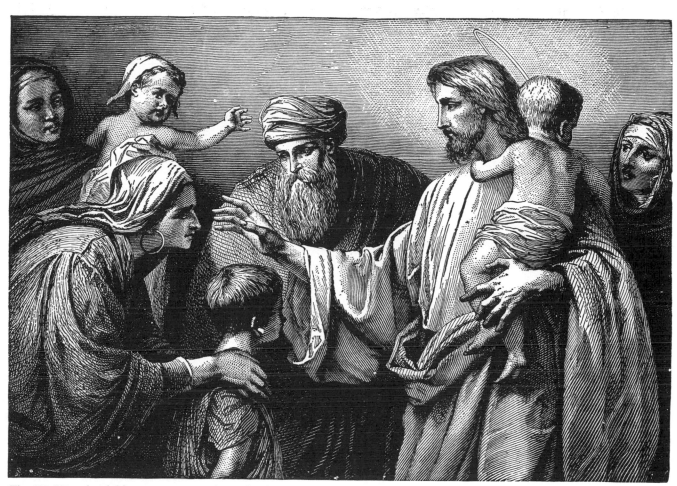

Fig. 111: "'Let the children come to me, do not hinder them; for to such belongs the kingdom of God'" (10:14).

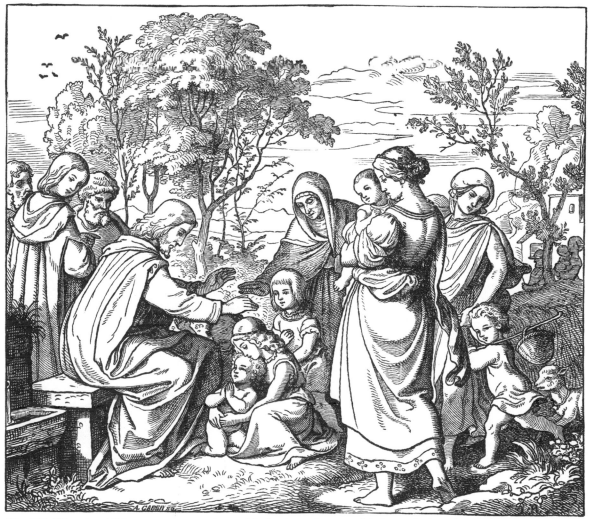

Fig. 112: "'Let the children come to me, do not hinder them; for to such belongs the kingdom of God'" (10:14).

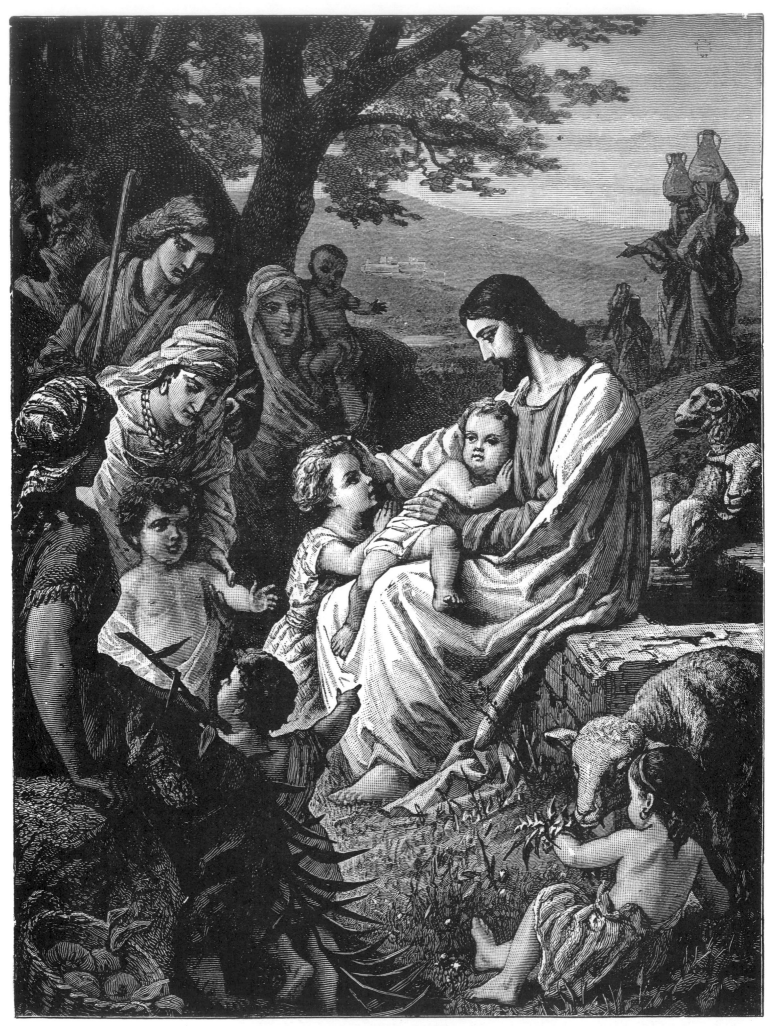

Fig. 113: "'Let the children come to me, do not hinder them; for to such belongs the kingdom of God'" (10:14).

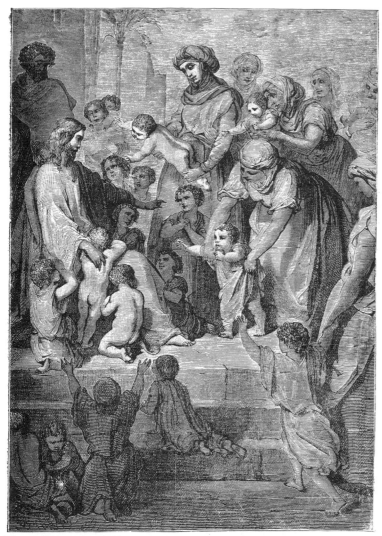

Fig. 114: "'Let the children come to me, do not hinder them; for to such belongs the kingdom of God'" (10:14).

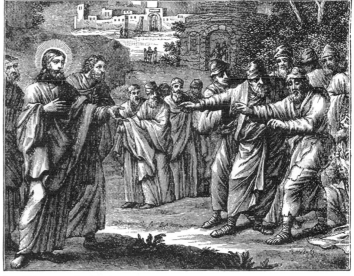

Fig. 116: Jesus healing Bartimeus (10:46–52).

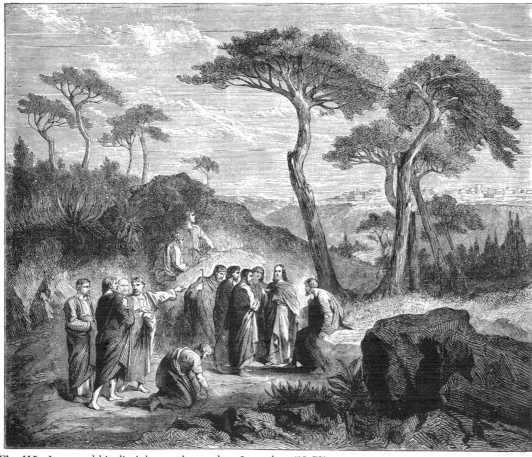

Fig. 115: Jesus and his disciples on the road to Jerusalem (10:32).

Mark 51

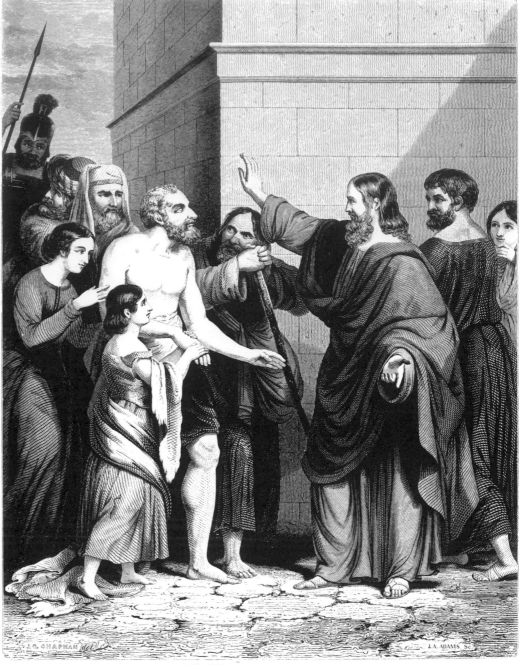

Fig. 117: Jesus healing Bartimeus (10:46–52).

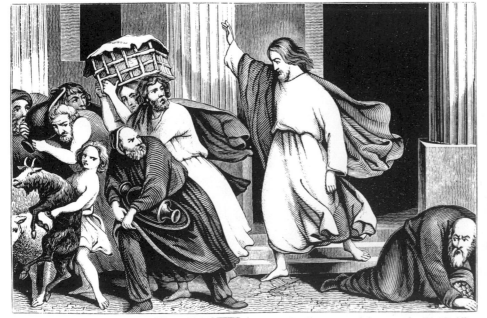

Fig. 118: Jesus driving the buyers and sellers out of the temple (11:15–17).

Fig. 119: Two disciples following the man into the house to prepare the passover (14:13–16).

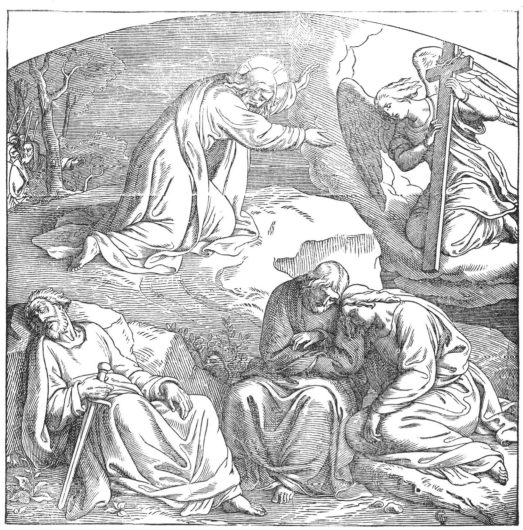

Fig. 120: The Agony in the Garden (14:32–42).

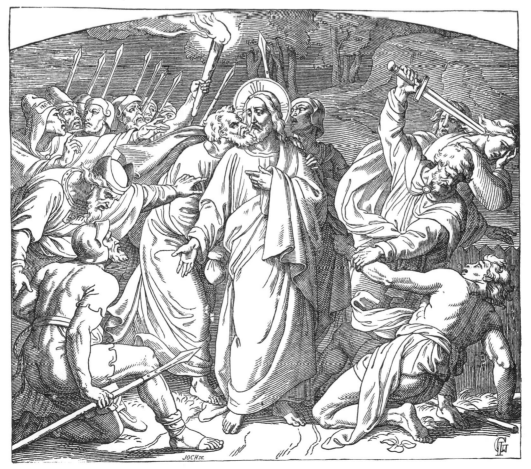

Fig. 121: Judas betraying Jesus with a kiss (14:44–47).

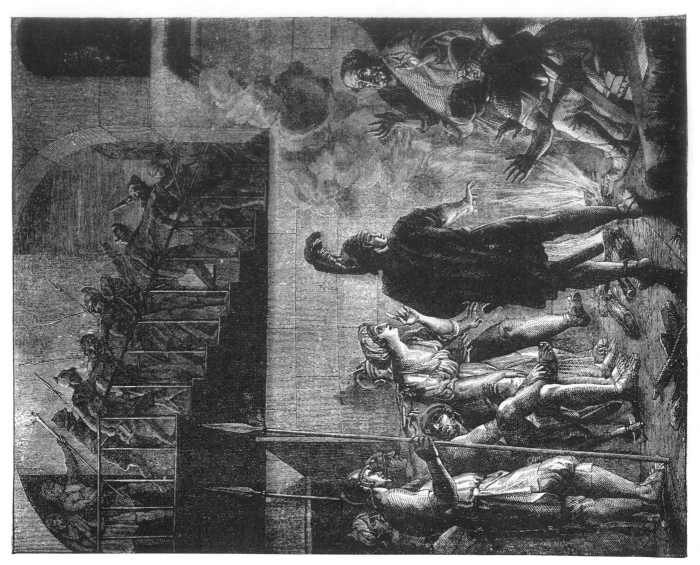

Fig. 124: Peter denying Jesus (14:66–72).

Fig. 122: Jesus before the high priest (14:53).

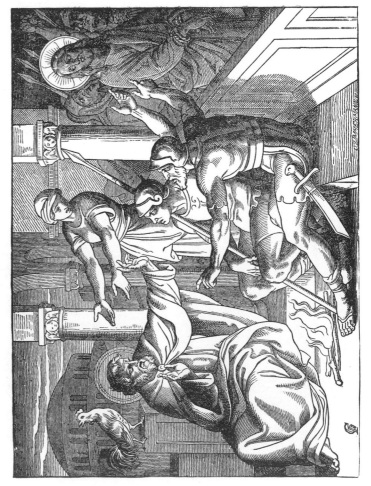

Fig. 123: Peter denying Jesus (14:66–72).

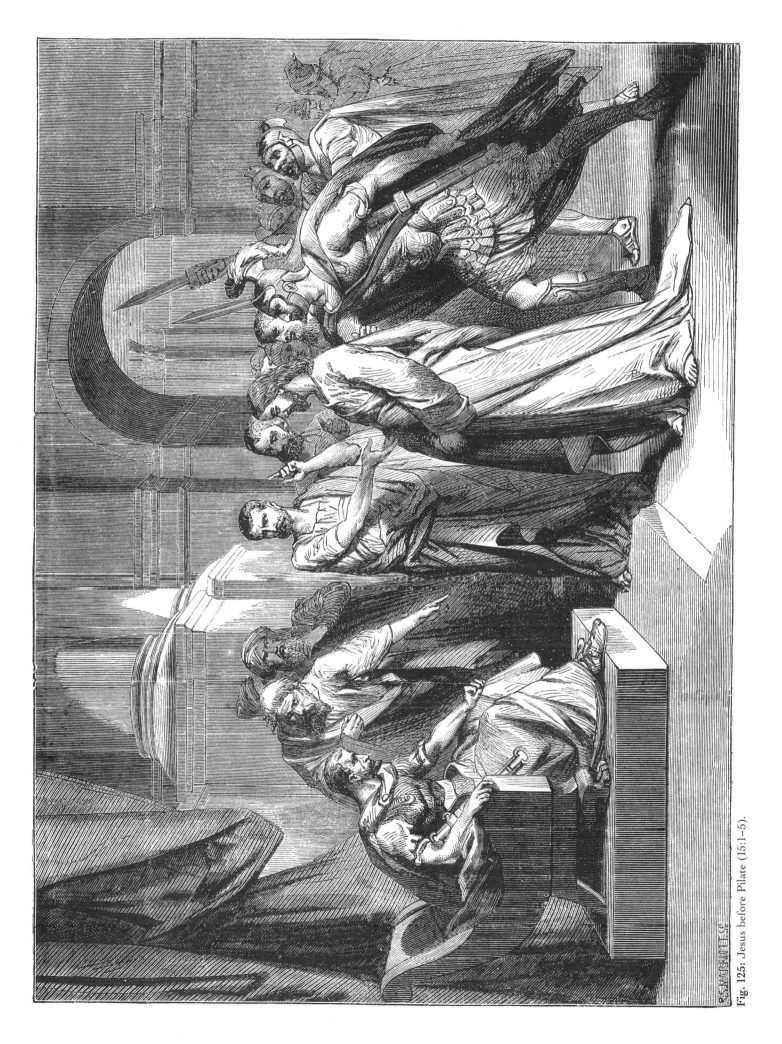

Fig. 125: Jesus before Pilate (15:1–5).

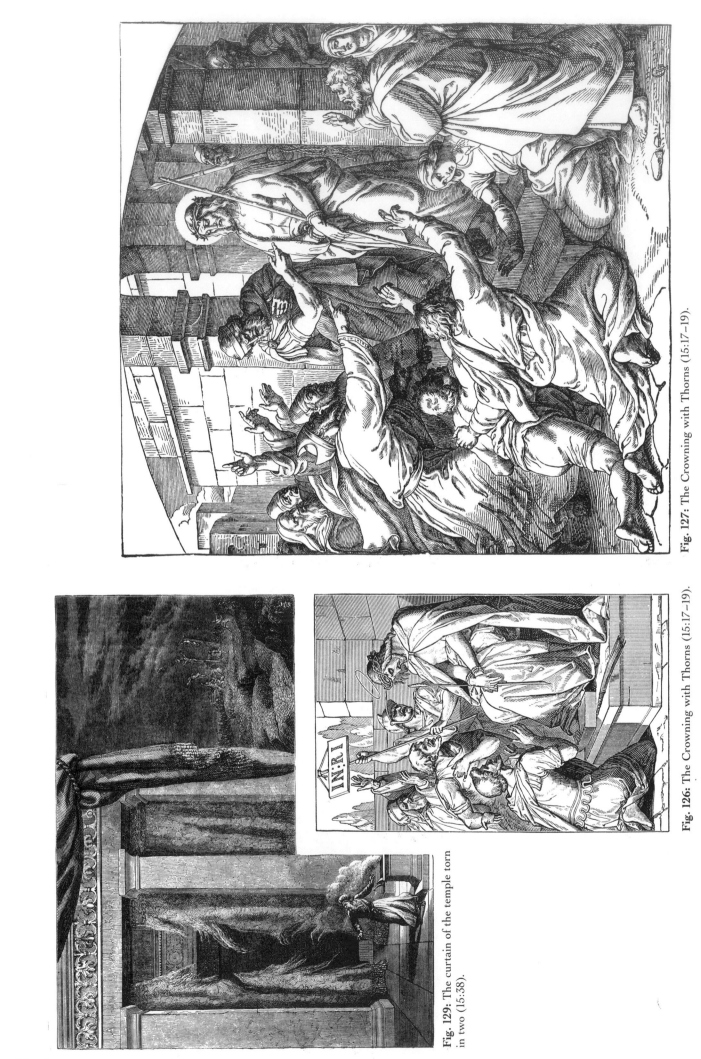

Fig. 127: The Crowning with Thorns (15:17–19).

Fig. 126: The Crowning with Thorns (15:17–19).

Fig. 129: The curtain of the temple torn in two (15:38).

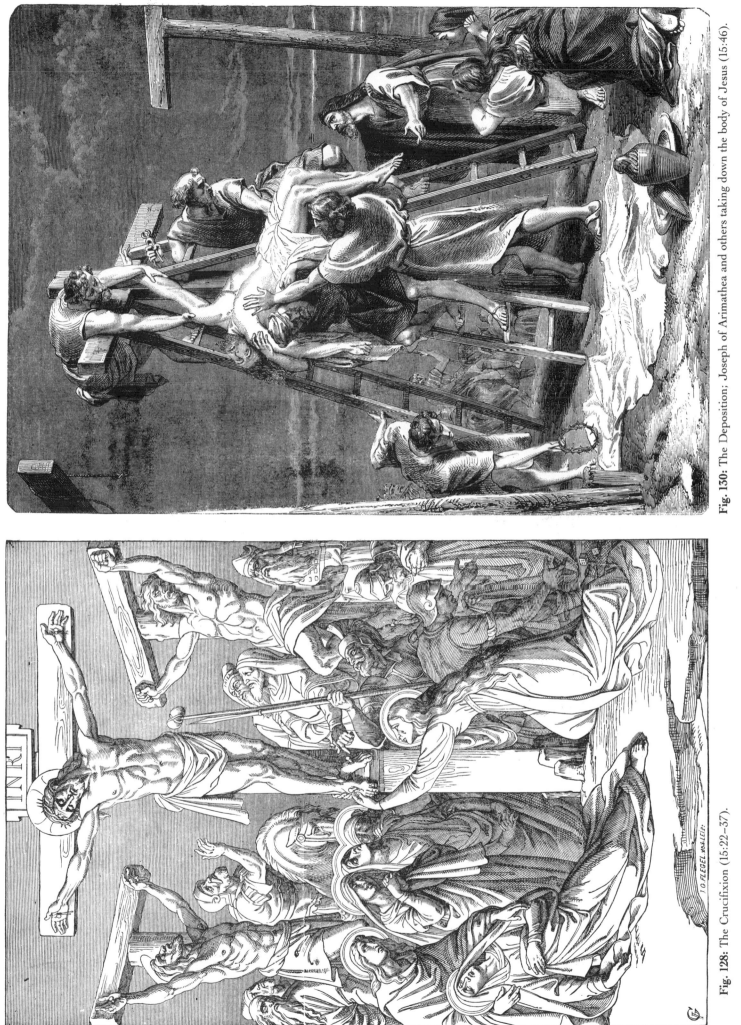

Fig. 130: The Deposition; Joseph of Arimathea and others taking down the body of Jesus (15:46).

Fig. 128: The Crucifixion (15:22–37).

TO FLEGEL WALLEI.

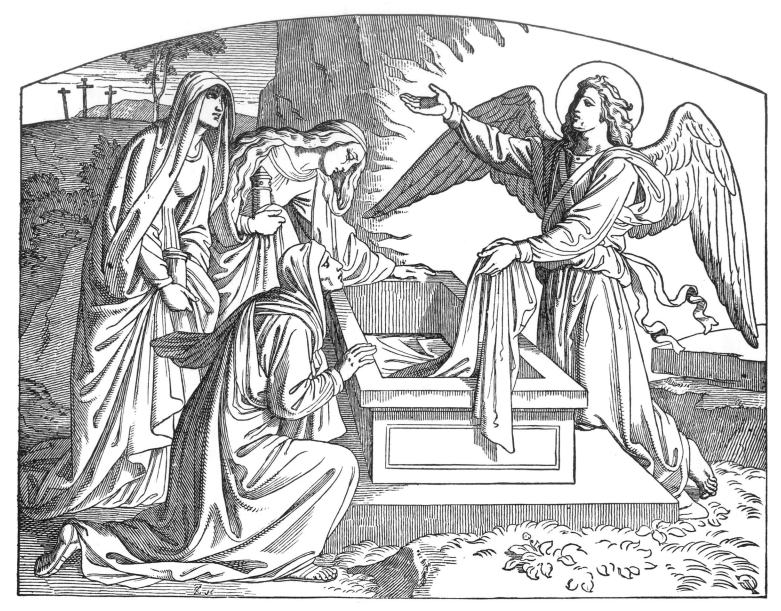

Fig. 131: Mary Magdalene, Salome and Mary the mother of James at the empty tomb (16:1–6).

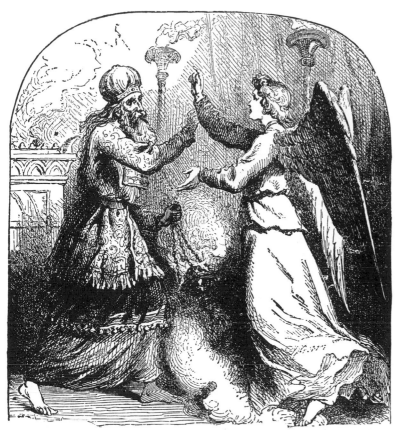

Fig. 132: The angel Gabriel appearing to Zacharias (1:8–20).

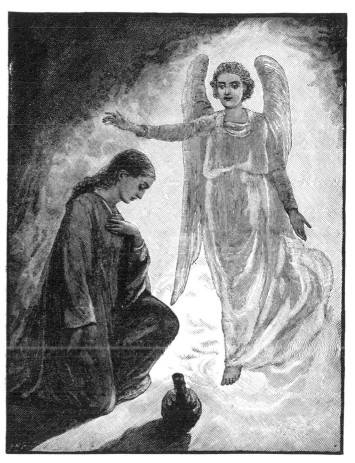

Fig. 133: The Annunciation to Mary by the angel Gabriel (1:26–38).

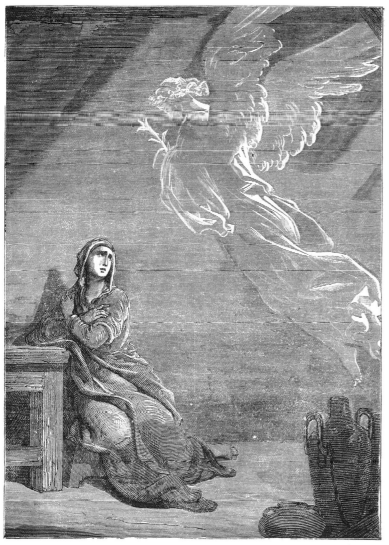

Fig. 134: The Annunciation to Mary by the angel Gabriel (1:26–38).

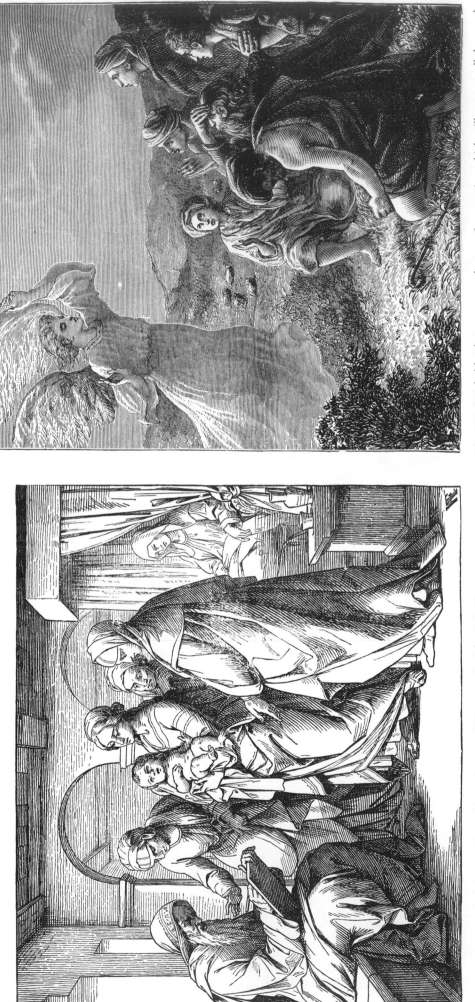

Fig. 137: "Behold, I bring you good news of a great joy which will come to all the people; for to you is born this day in the city of David a Savior, who is Christ the Lord" (2:10–11).

Fig. 135: Zacharias asked for a writing tablet and wrote, "'His name is John.'" (1:63).

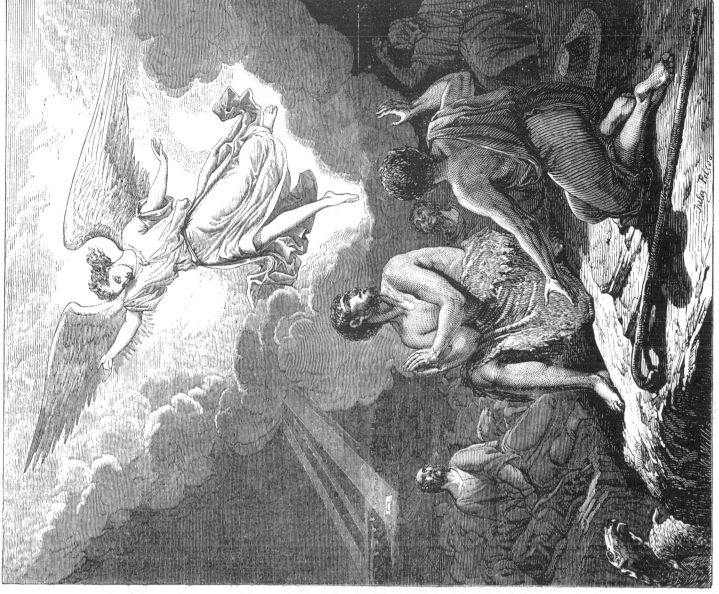

Fig. 138: "'Behold, I bring you good news of a great joy which will come to all the people; for to you is born this day in the city of David a Savior, who is Christ the Lord'" (2:10–11).

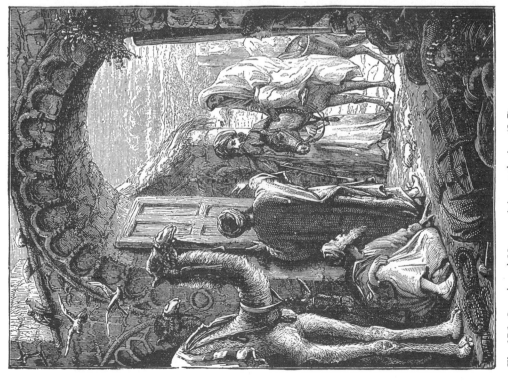

Fig. 136: Joseph and Mary arriving at the inn (2:7).

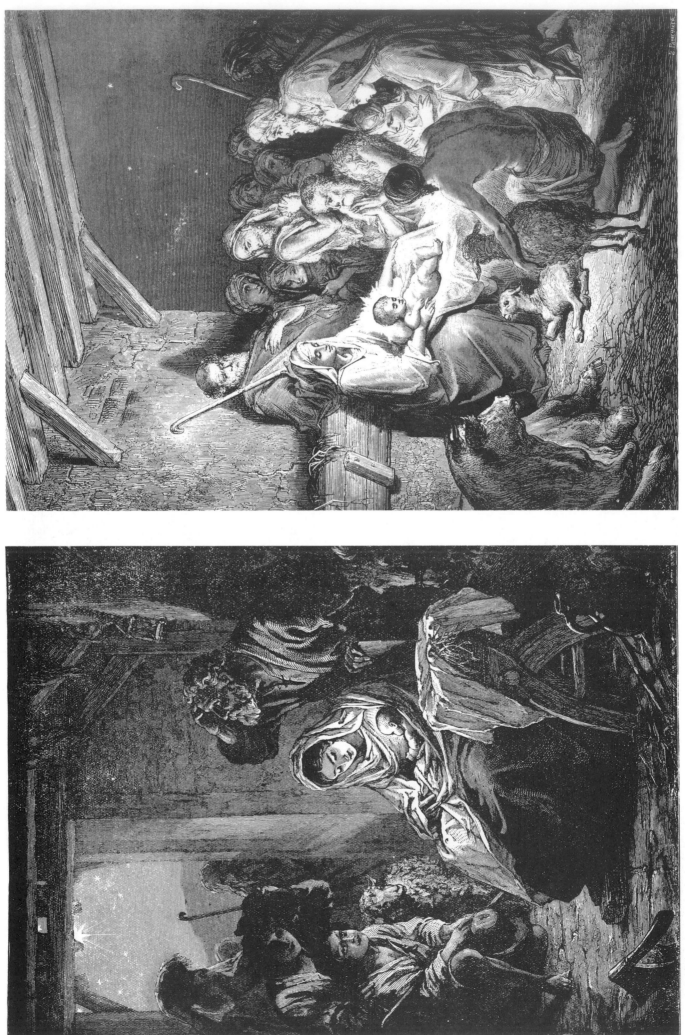

Fig. 140: The Nativity (2:16).

Fig. 139: The Nativity (2:16).

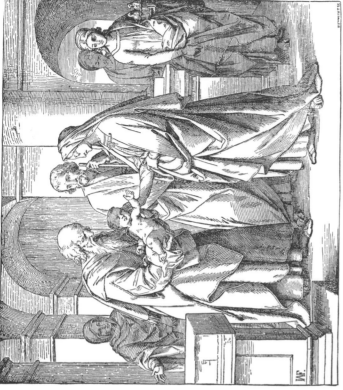

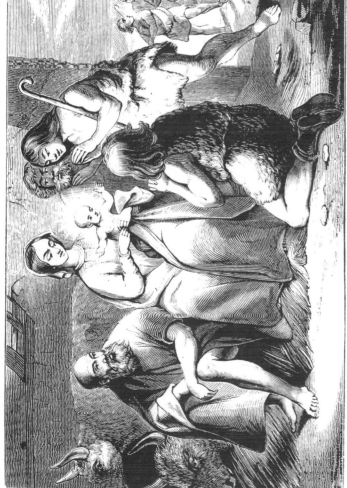

Fig. 141: The Nativity (2:16).

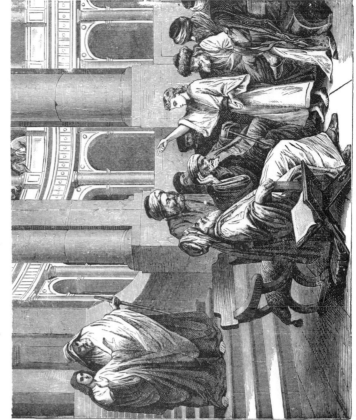

Fig. 142: The Presentation in the Temple; Simeon and Anna giving thanks to God for the baby Jesus (2:22–38).

Fig. 144: Jesus among the Doctors (2:46–47).

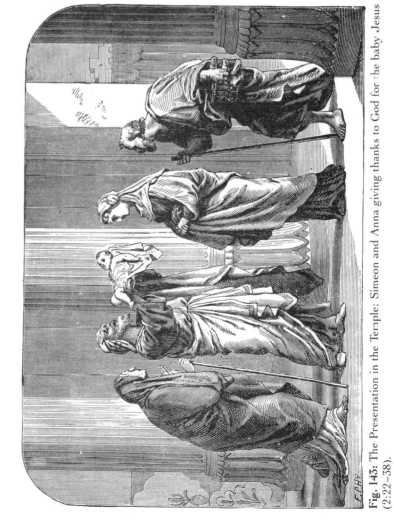

Fig. 143: The Presentation in the Temple; Simeon and Anna giving thanks to God for the baby Jesus (2:22–38).

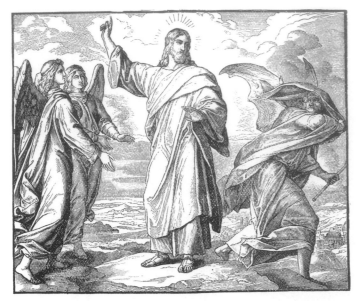

Fig. 145: The Temptation in the Wilderness (4:5–8).

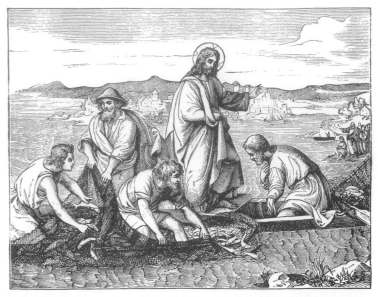

Fig. 148: The miraculous draft of fishes and the calling of Peter, James and John (5:4–11).

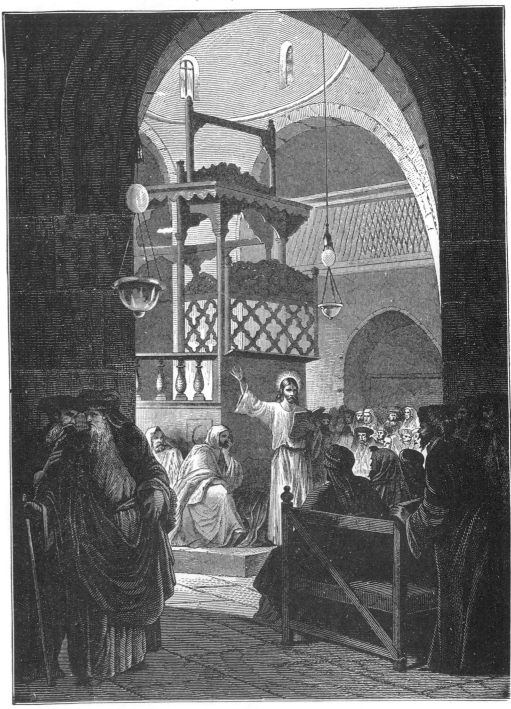

Fig. 146: Jesus reading in the synagogue (4:16–19).

64 *Luke*

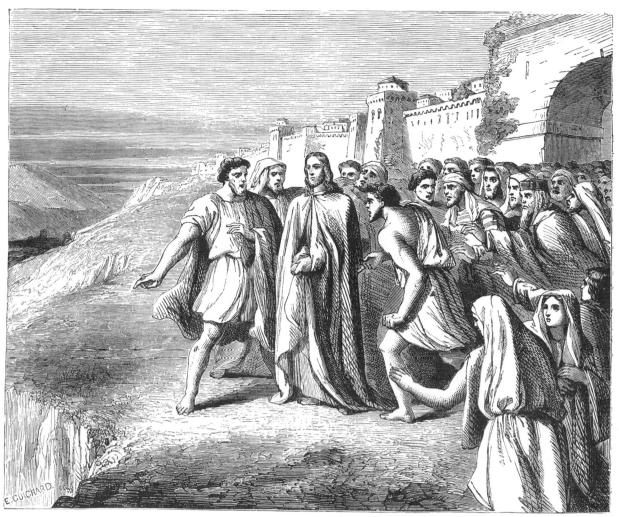

Fig. 147: The Jews leading Jesus to the edge of the hill (4:28–30).

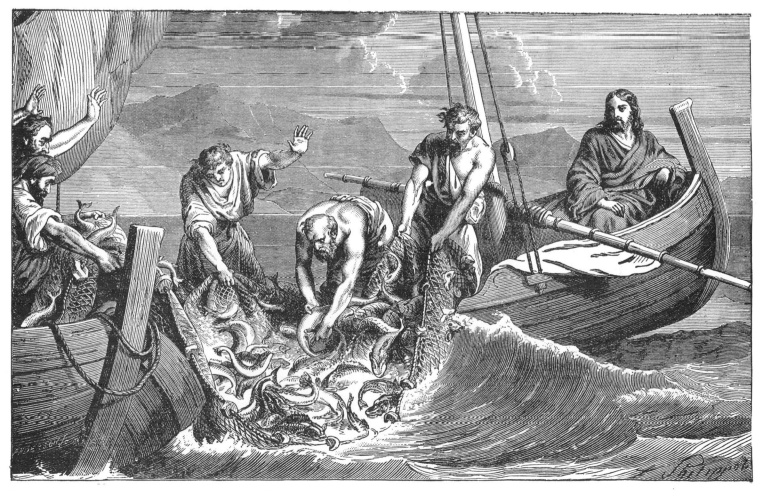

Fig. 149: The miraculous draft of fishes and the calling of Peter, James and John (5:4–11).

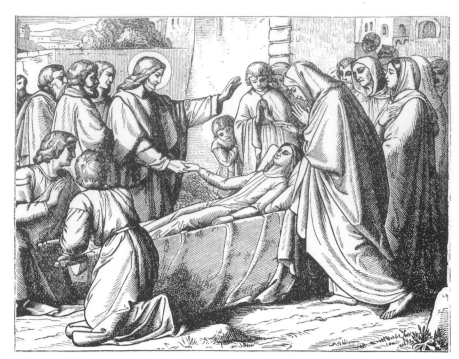

Fig. 150: "'Young man, I say to you, arise'" (7:14).

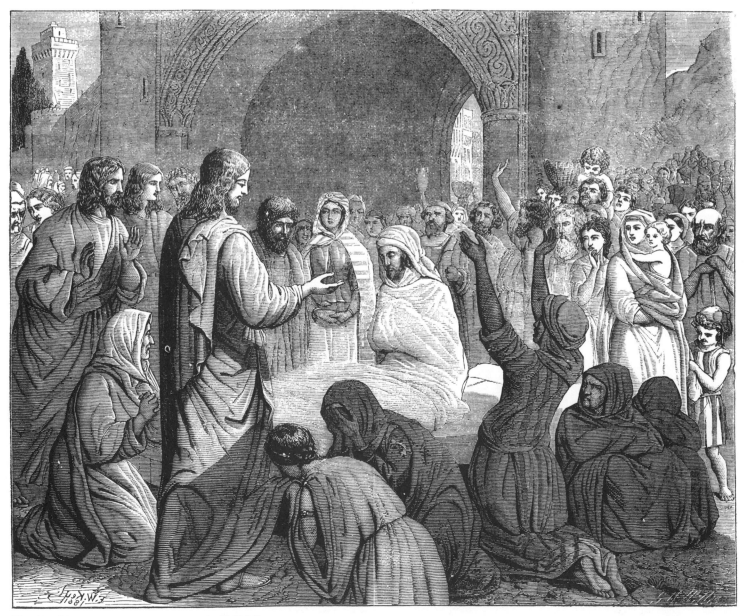

Fig. 151: "'Young man, I say to you, arise'" (7:14).

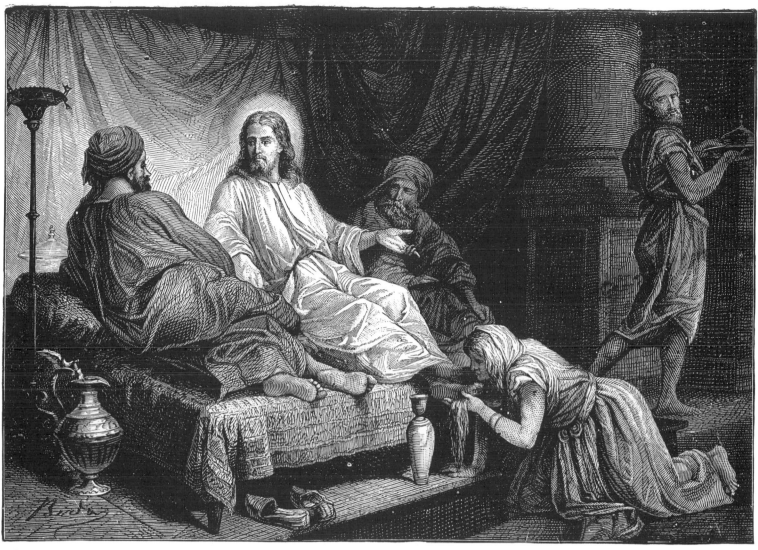

Fig. 152: Jesus at supper with Simon the Pharisee (7:44–48).

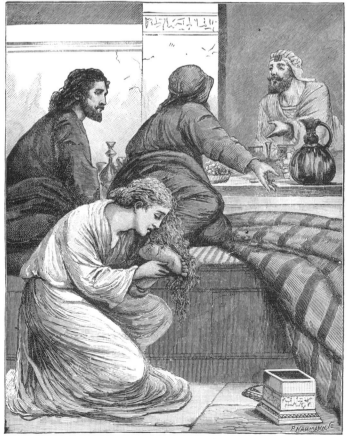

Fig. 153: Jesus at supper with Simon the Pharisee (7:44–48).

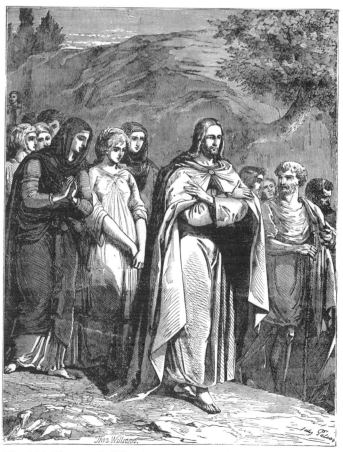

Fig. 154: The people following Jesus (8:1–3).

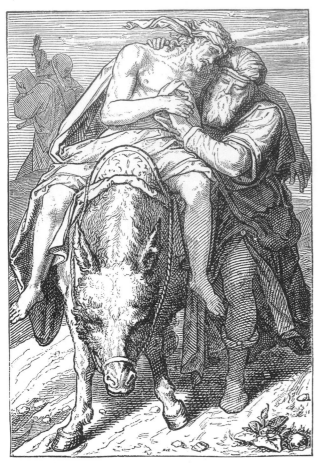

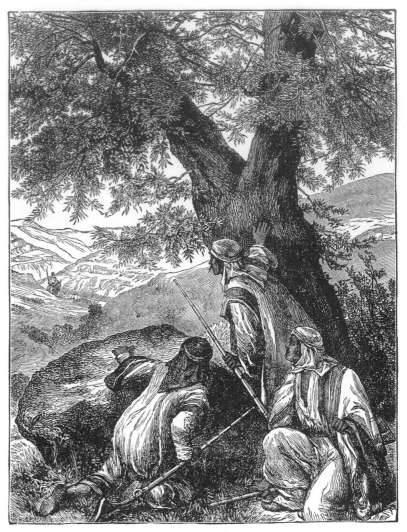

Fig. 156: The good Samaritan (10:30–34). **Fig. 155:** Robbers lying in wait (10:30).

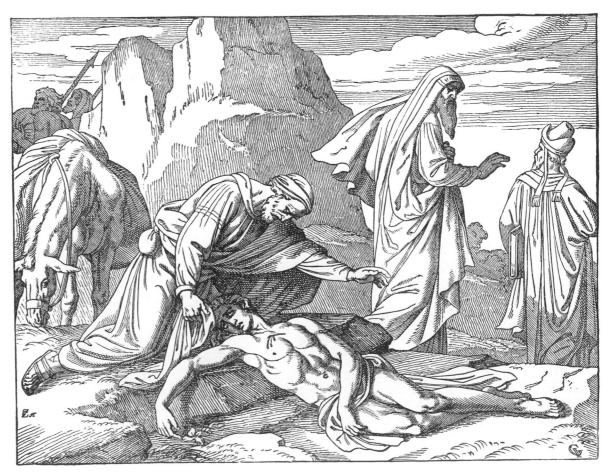

Fig. 157: The good Samaritan (10:30–34).

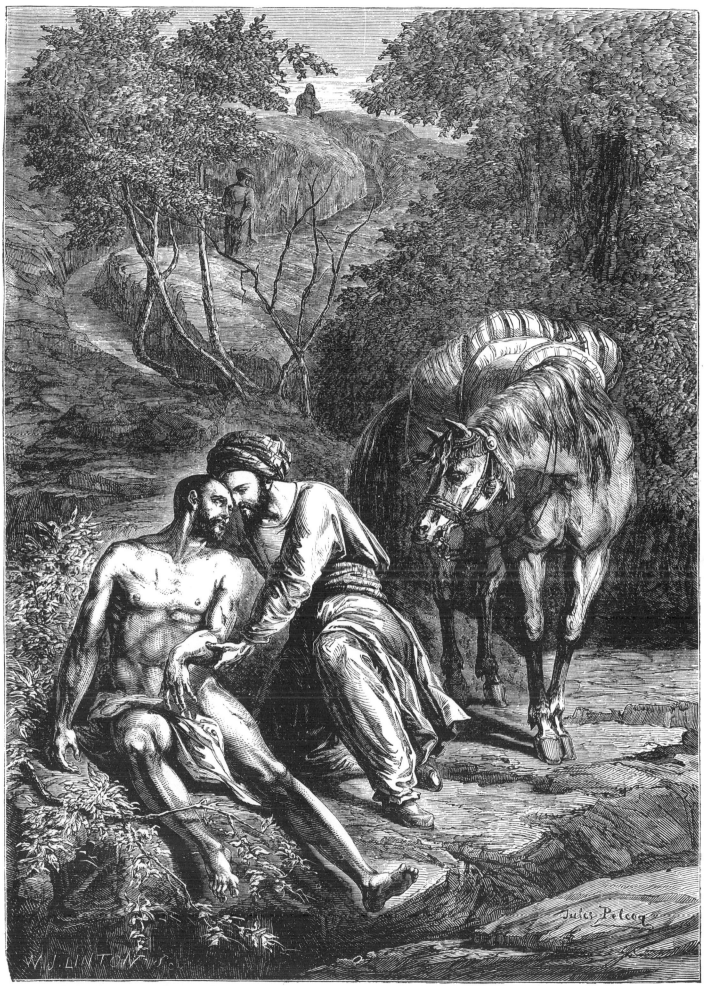

Fig. 158: The good Samaritan (10:30–34).

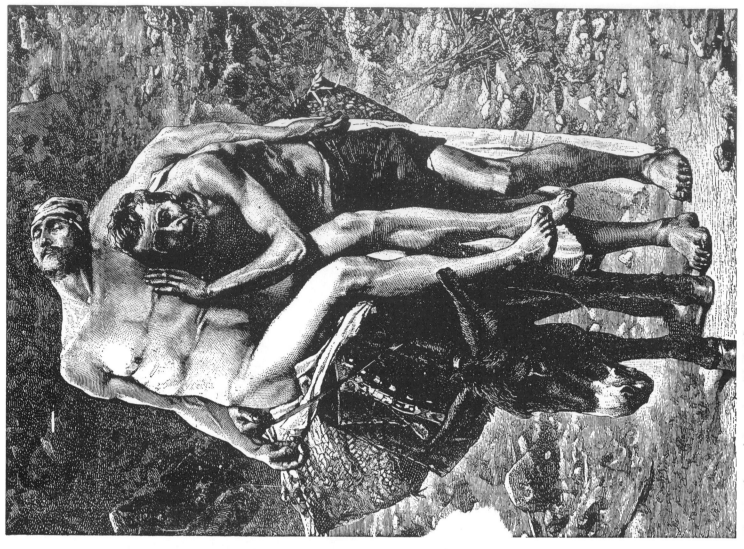

Fig. 161: The good Samaritan (10:30–34).

Fig. 159: The good Samaritan (10:30–34).

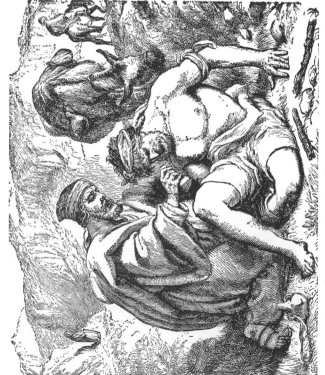

Fig. 160: The good Samaritan (10:30–34).

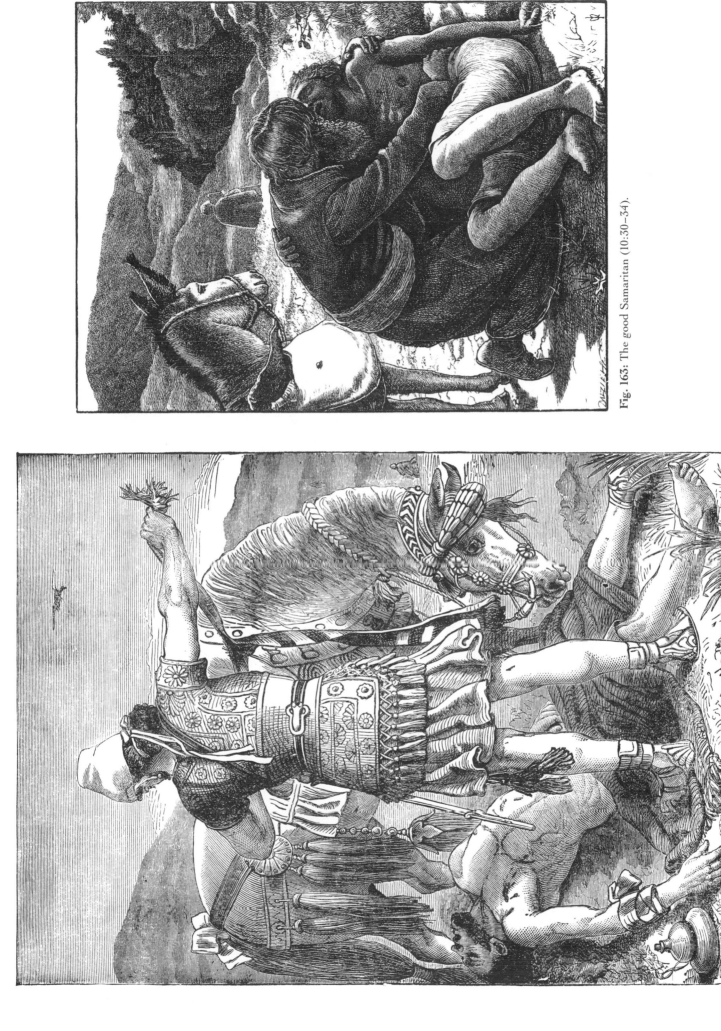

Fig. 163: The good Samaritan (10:30–34).

Fig. 162: The good Samaritan (10:30–34).

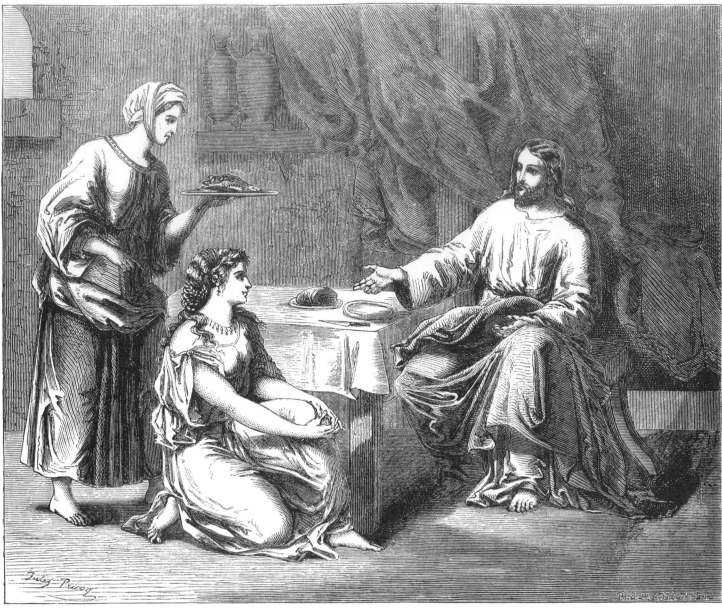

Fig. 164: Jesus in the house of Martha and Mary at Bethany (10:38–42).

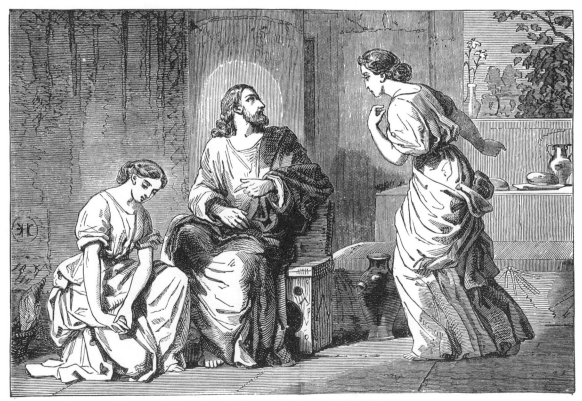

Fig. 165: Jesus in the house of Martha and Mary at Bethany (10:38–42).

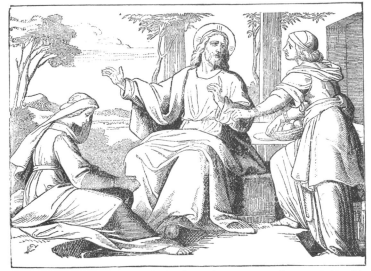

Fig. 166: Jesus in the house of Martha and Mary at Bethany (10:38–42).

Fig. 167: The importunate friend (11:5–13).

Fig. 168: The rich man does not have room for his crops (12:17).

Fig. 169: The rich man building larger barns (12:18).

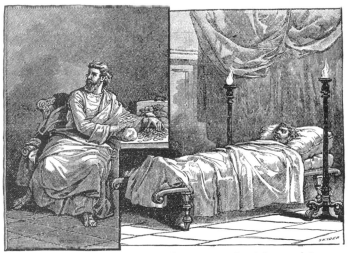

Fig. 170: The rich man counting his money; the rich man dying (12:19–21).

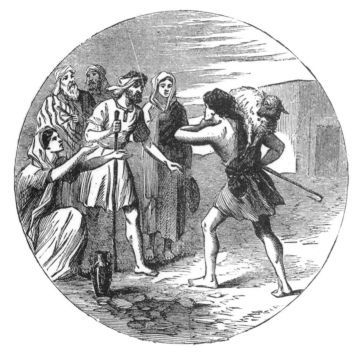

Fig. 172: The lost sheep (15:4–7).

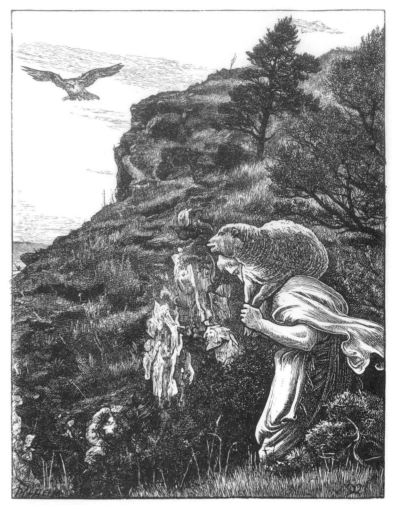

Fig. 173: The lost sheep (15:4–7).

Fig. 174: The lost piece of silver (15:8–10).

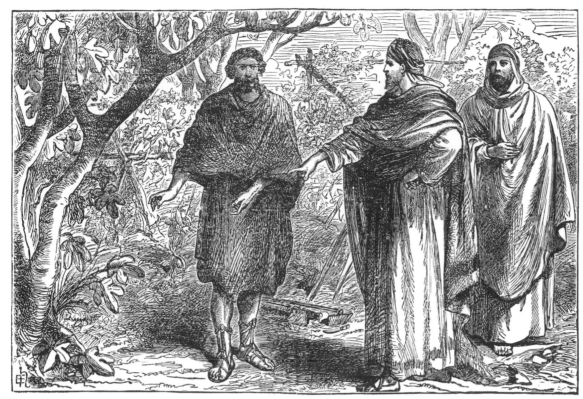

Fig. 171: The barren fig tree (13:6–9).

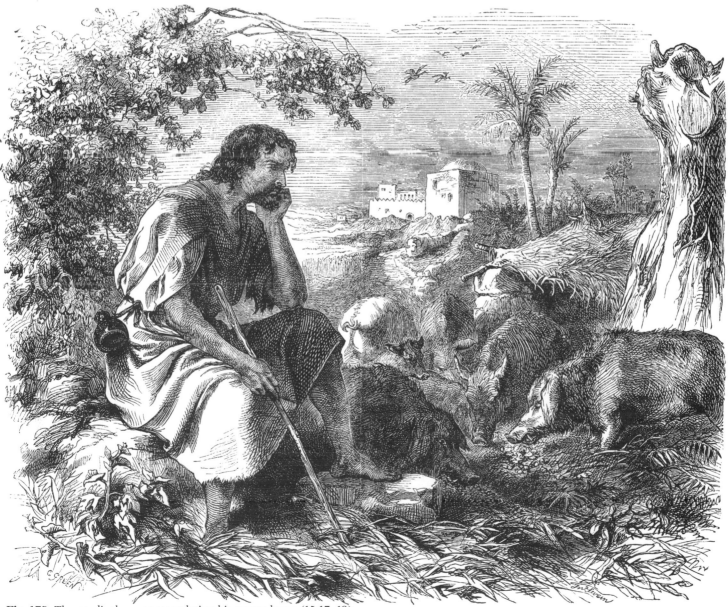

Fig. 175: The prodigal son contemplating his return home (15:17–19).

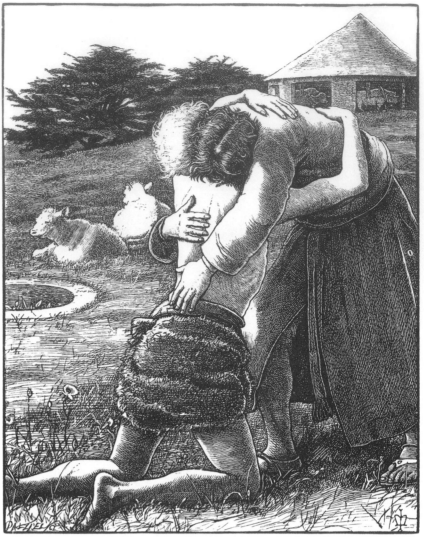

Fig. 176: The return of the prodigal son (15:20–21).

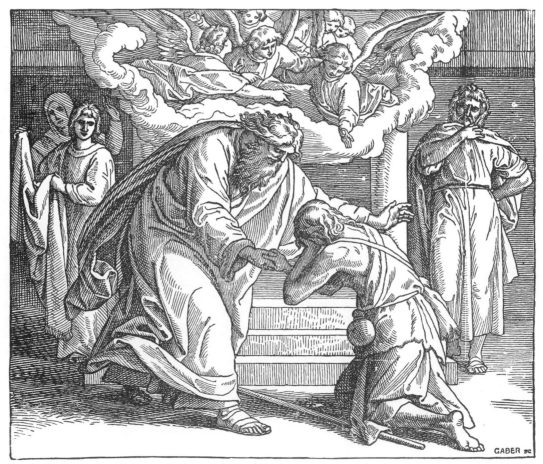

Fig. 177: The return of the prodigal son (15:20–21).

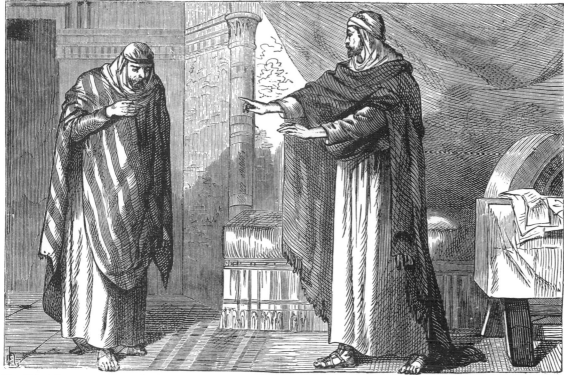

Fig. 179: The unjust steward (16:1–2).

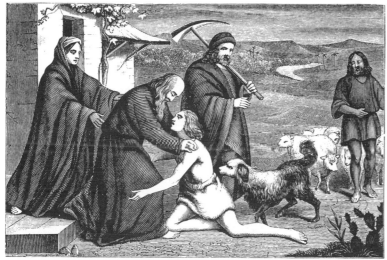

Fig. 178: The return of the prodigal son (15:20–21).

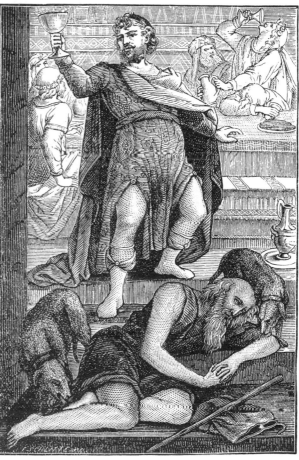

Fig. 181: Lazarus at the rich man's gate (16:19–21).

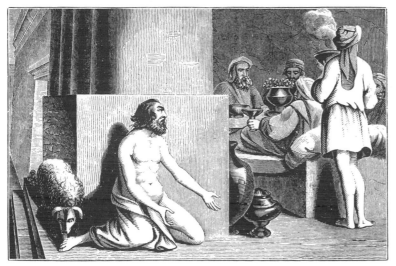

Fig. 180: Lazarus at the rich man's gate (16:19–21).

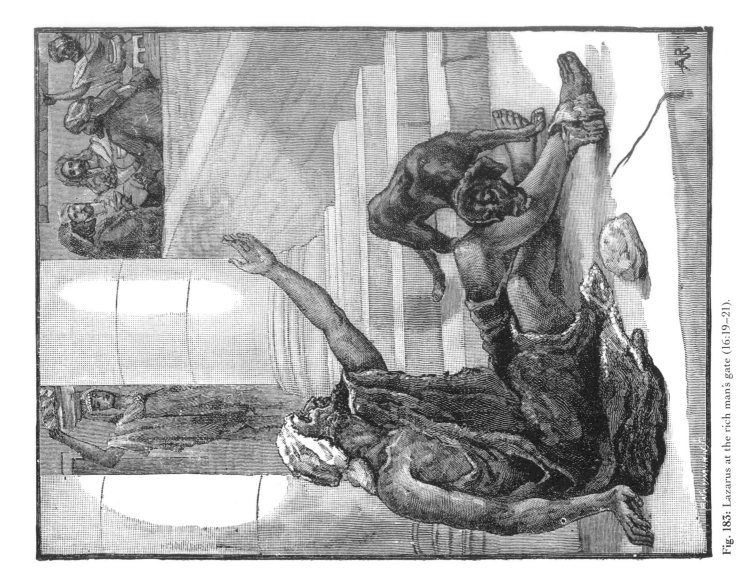

Fig. 183: Lazarus at the rich man's gate (16:19–21).

Fig. 182: Lazarus at the rich man's gate (16:19–21).

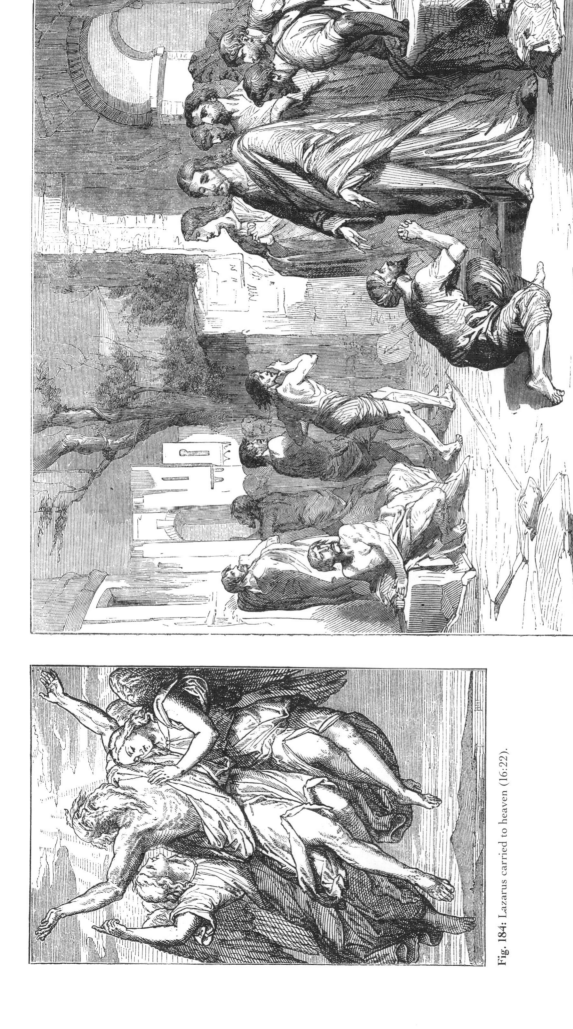

Fig. 185: The thankful leper (17:11–19).

Fig. 184: Lazarus carried to heaven (16:22).

Fig. 186: The thankful leper (17:11–19).

Fig. 188: The Pharisee and the publican (18:10–14).

Fig. 189: The Pharisee and the publican (18:10–14).

Fig. 187: The unjust judge (18:2–8).

Fig. 190: The Pharisee and the publican (18:10–14).

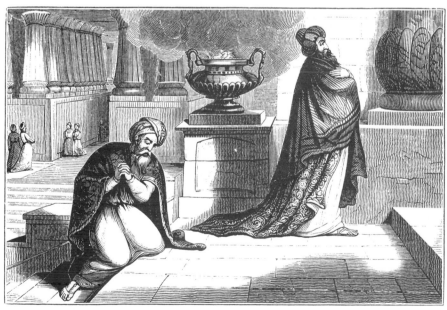

Fig. 191: The Pharisee and the publican (18:10–14).

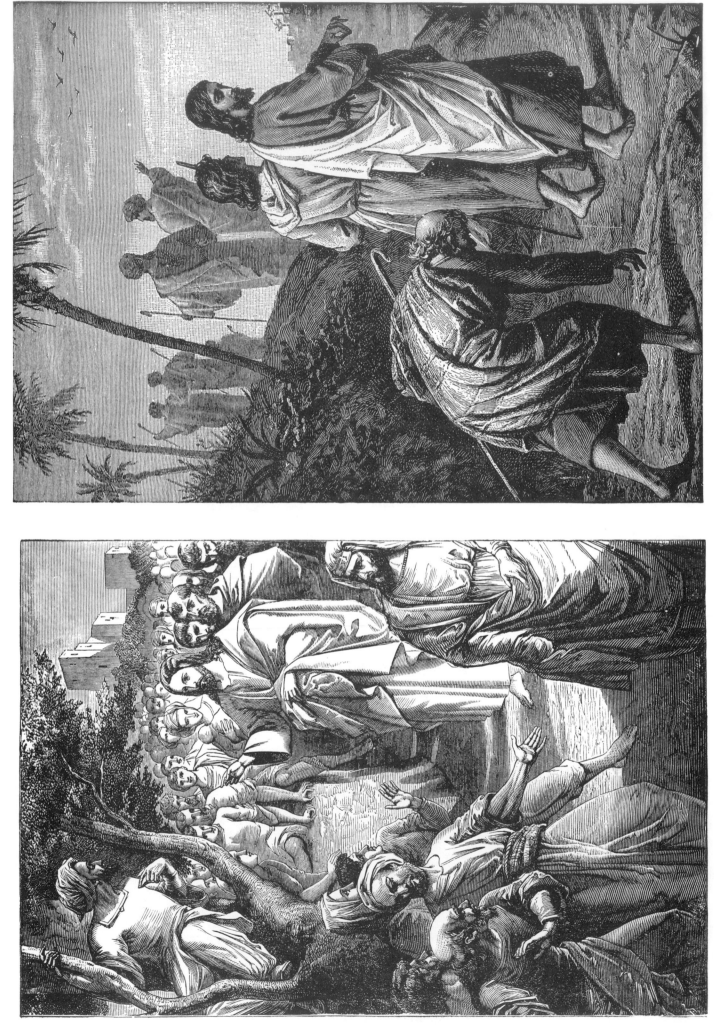

Fig. 196: Jesus and his disciples crossing the Mount of Olives (22:39).

Fig. 192: Zacchaeus in the tree (19:1-6).

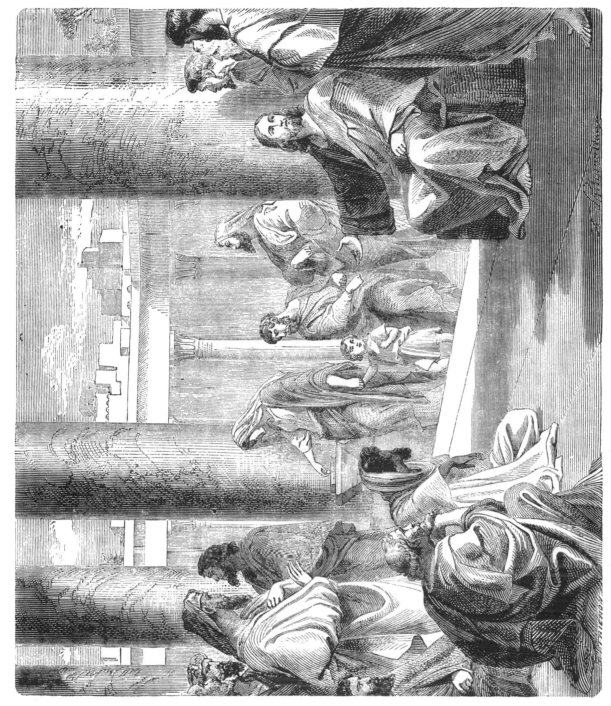

Fig. 195: "'Truly I tell you, this poor widow has put in more than all of them'" (21:3).

Fig. 193: Zacchaeus in the tree (19:1–6).

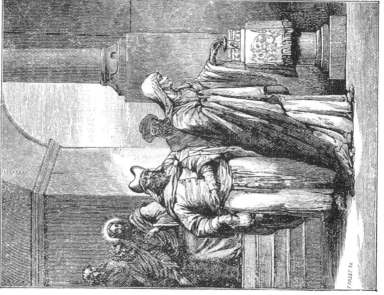

Fig. 194: "'Truly I tell you, this poor widow has put in more than all of them'" (21:3).

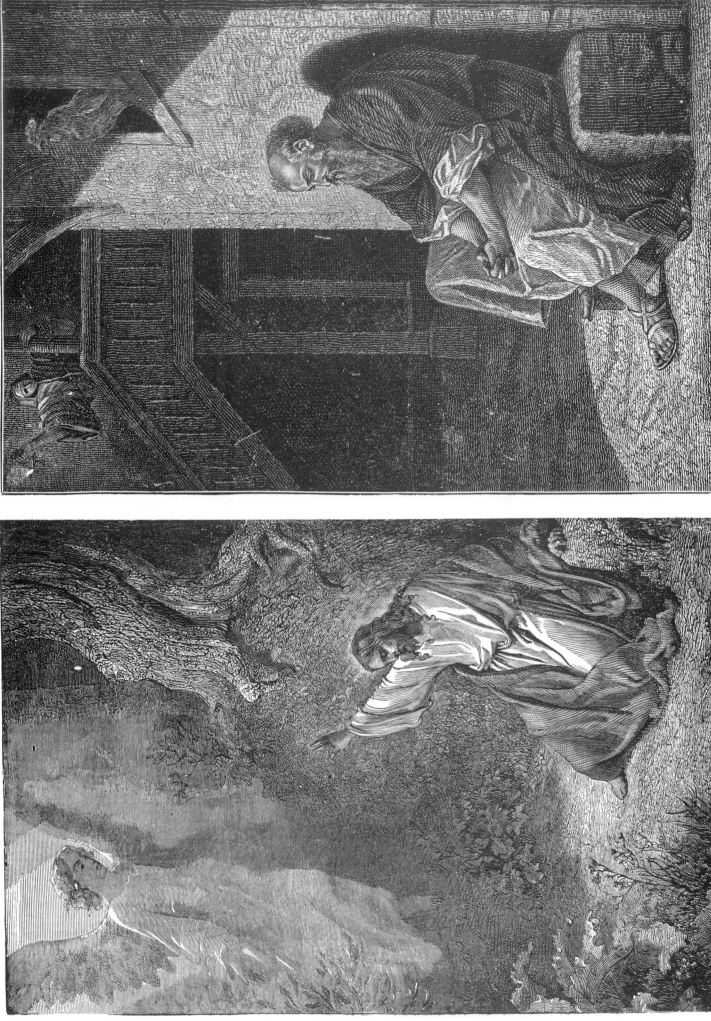

Fig. 198: The repentance of Peter (22:62).

Fig. 197: The Agony in the Garden (22:41–44).

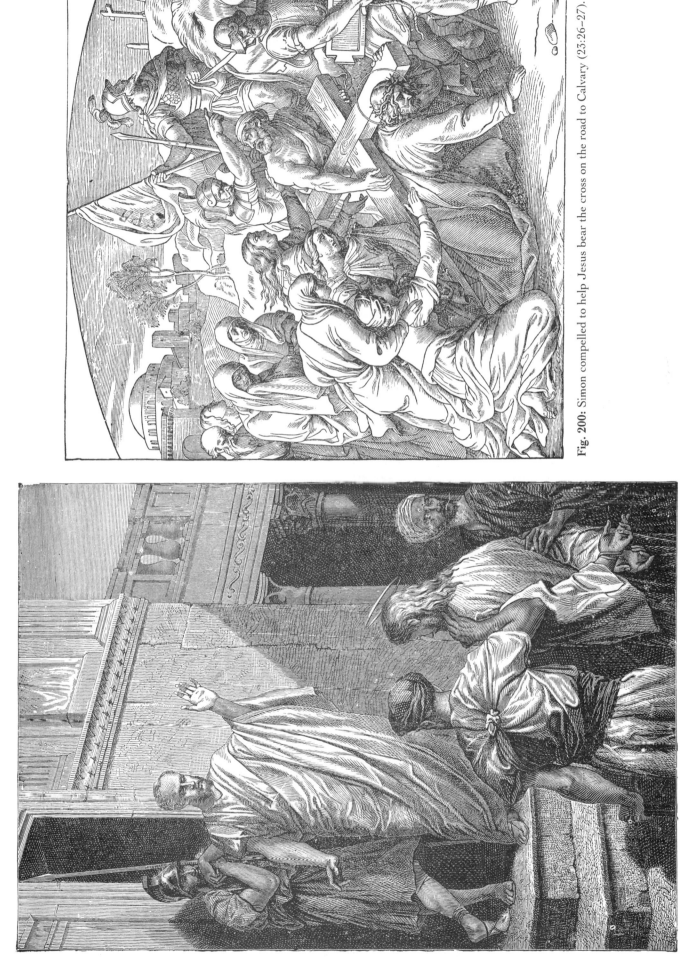

Fig. 200: Simon compelled to help Jesus bear the cross on the road to Calvary (23:26–27).

Fig. 199: Jesus before Pilate (23:13–16).

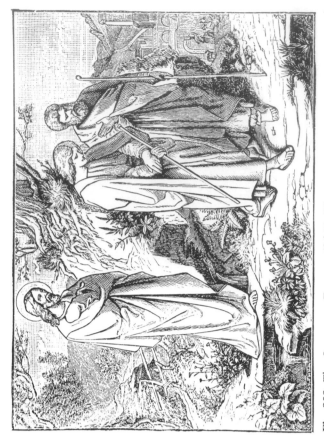

Fig. 202: The Journey to Emmaus (24:13–16).

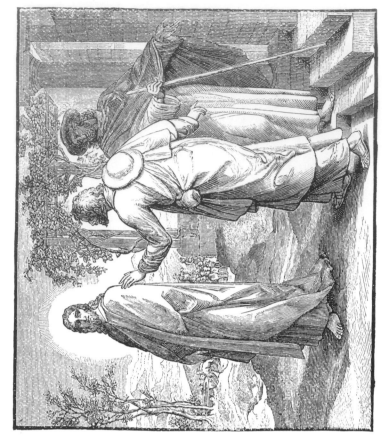

Fig. 204: The disciples said to Jesus when they reached Emmaus, "'Stay with us, for it is toward evening and the day is now far spent'" (24:28–29).

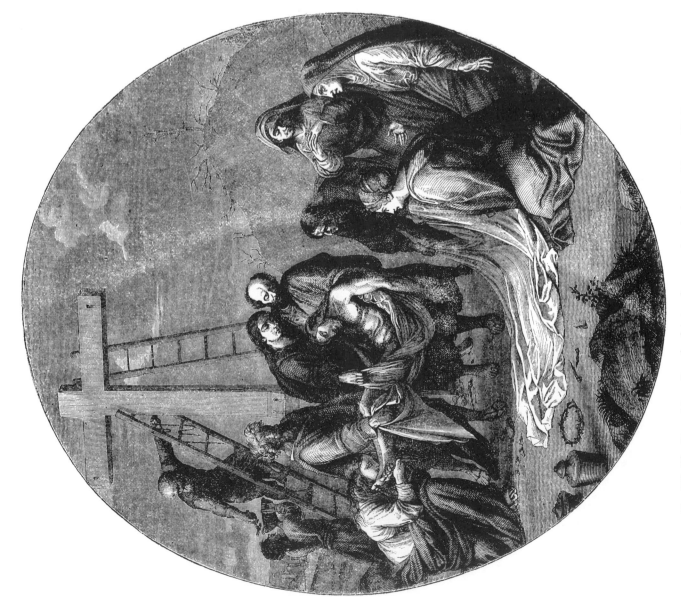

Fig. 201: The Deposition; Joseph of Arimathea carrying the body of Jesus (23:53).

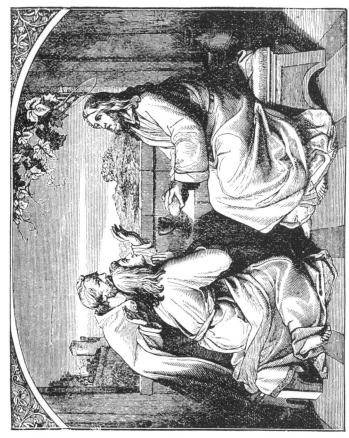

Fig. 205: The Supper at Emmaus (24:30–31).

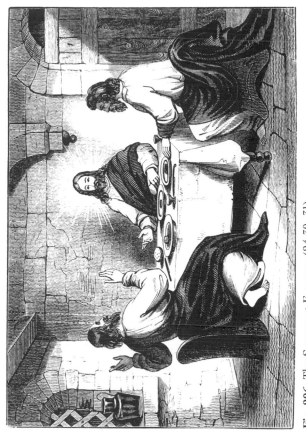

Fig. 206: The Supper at Emmaus (24:30–31).

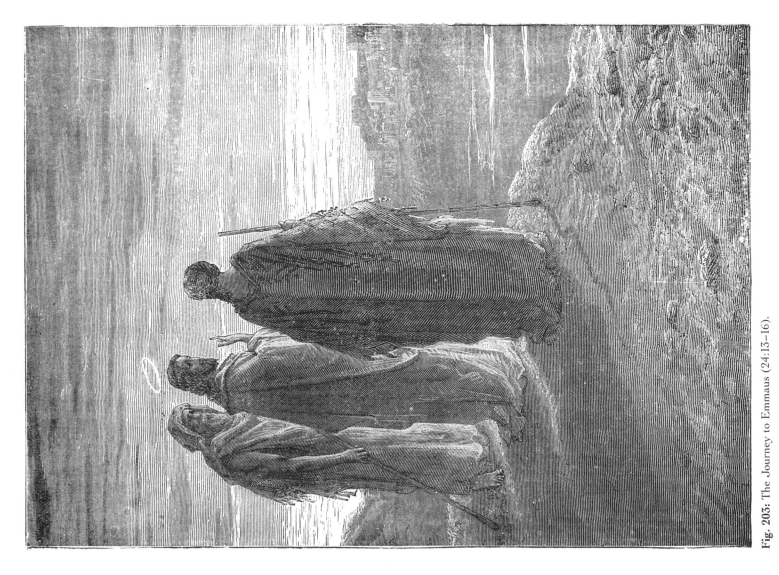

Fig. 203: The Journey to Emmaus (24:13–16).

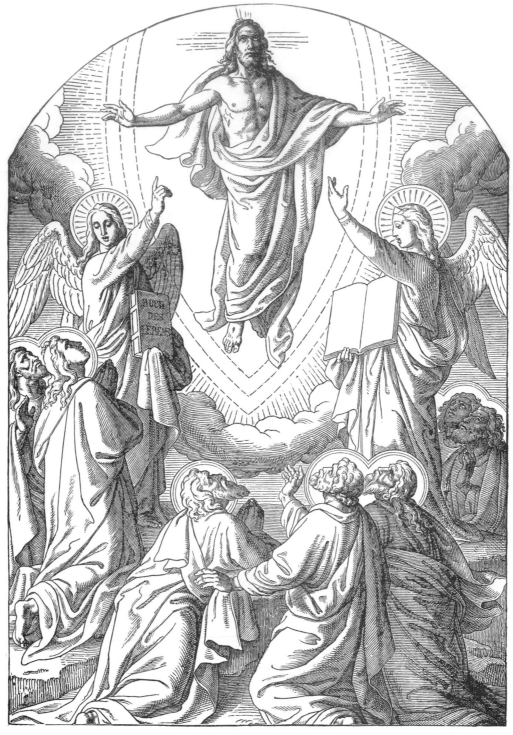

Fig. 207: The Ascension at Bethany (24:50–51).

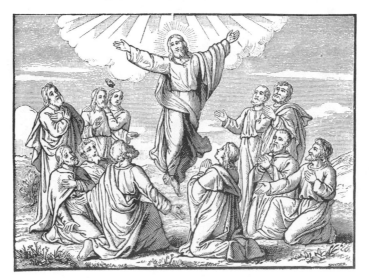

Fig. 208: The Ascension at Bethany (24:50–51).

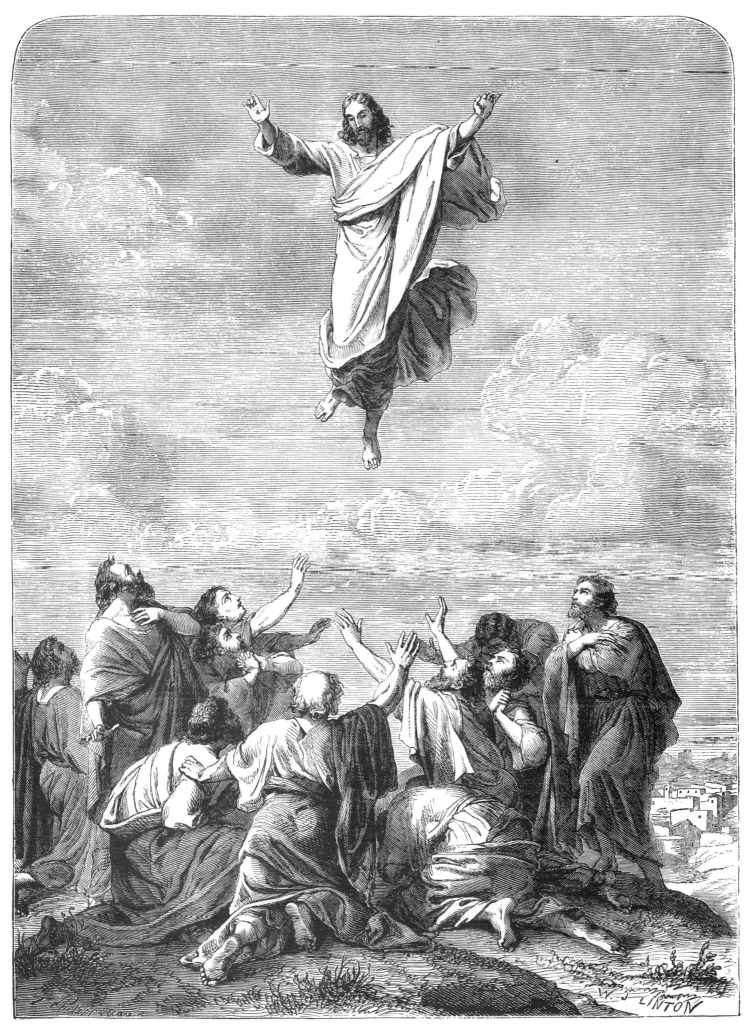

Fig. 209: The Ascension at Bethany (24:50–51).

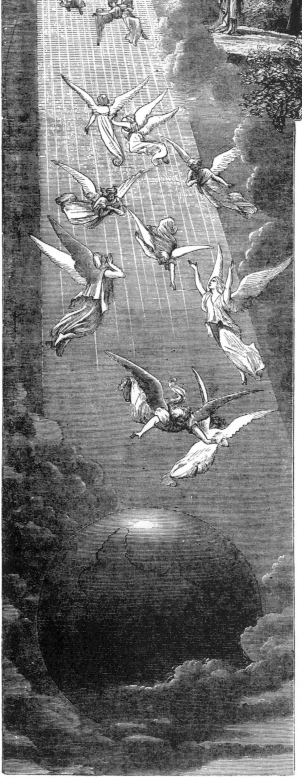

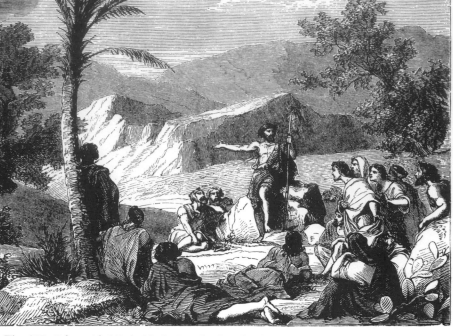

Fig. 210: John said, "'Behold, the Lamb of God, who takes away the sin of the world!'" (1:29).

Fig. 211: John said, "'Behold, the Lamb of God, who takes away the sin of the world!'" (1:29).

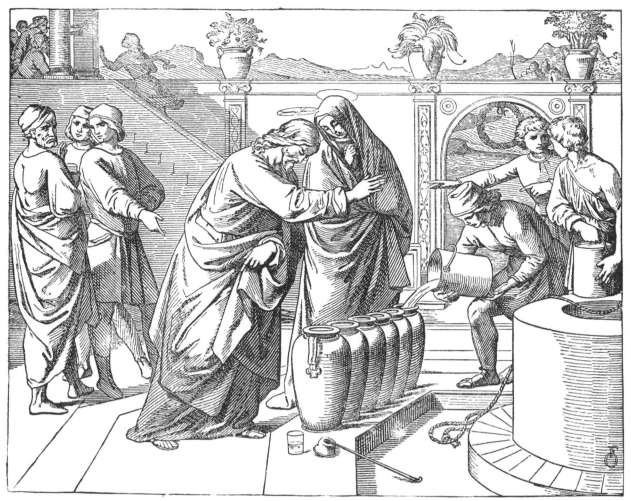

Fig. 212: The Marriage at Cana (2:1–11).

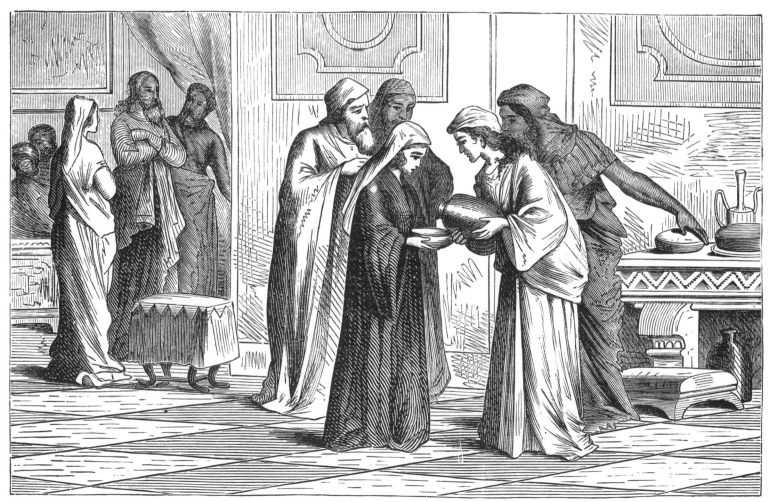

Fig. 213: The Marriage at Cana (2:1–11).

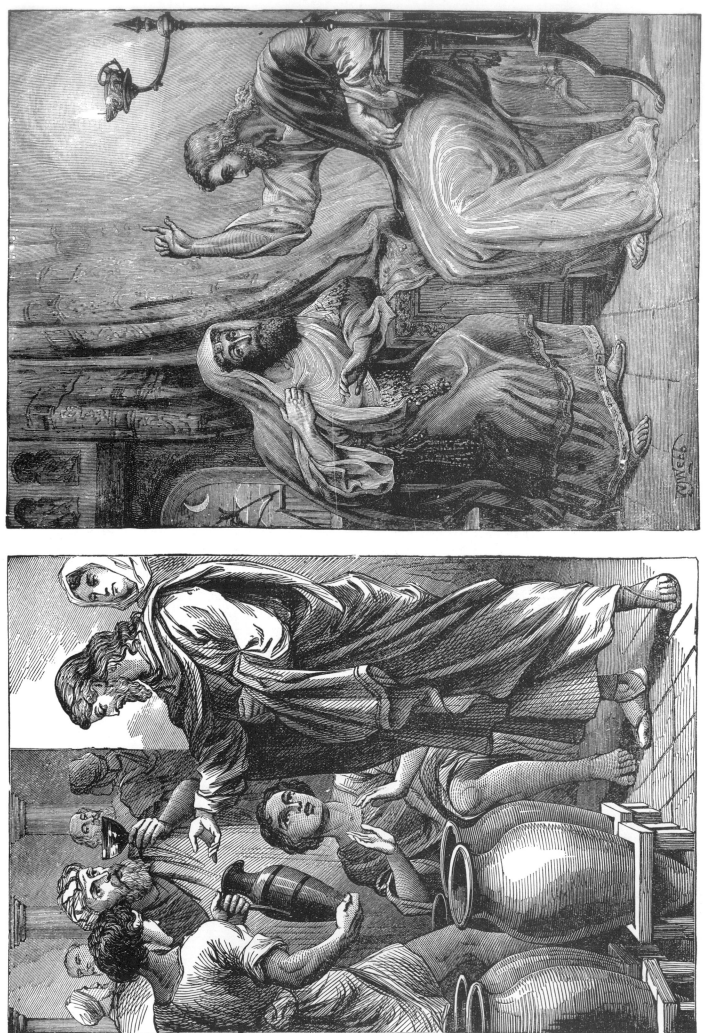

Fig. 215: Jesus instructing Nicodemus the Pharisee (3:1–15).

Fig. 214: The Marriage at Cana (2:1–11).

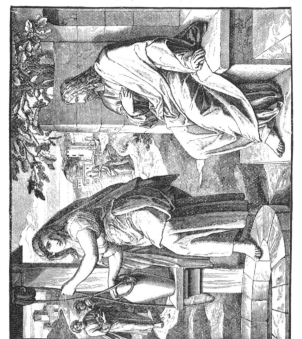

Fig. 217: Jesus and the woman of Samaria (4:7–26).

Fig. 218: Jesus and the woman of Samaria (4:7–26).

Fig. 216: Jesus and the woman of Samaria (4:7–26).

Fig. 220: "'Go; your son will live'" (4:50).

Fig. 219: Jesus and the woman of Samaria (4:7–26).

Fig. 222: The angel troubling the water in the Pool of Bethesda (5:4).

Fig. 221: The invalids at the Pool of Bethesda (5:2–3).

Fig. 223: Jesus healing the paralytic at the Pool of Bethesda (5:5–9).

Fig. 227: The woman taken in adultery before Jesus and the Pharisees (8:3–8).

Fig. 225: "'If any one thirst, let him come to me and drink'" (7:37).

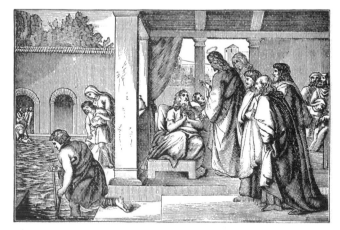

Fig. 224: Jesus healing the paralytic at the Pool of Bethesda (5:5–9).

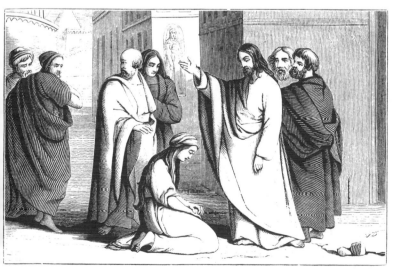

Fig. 226: The woman taken in adultery before Jesus and the Pharisees (8:3–8).

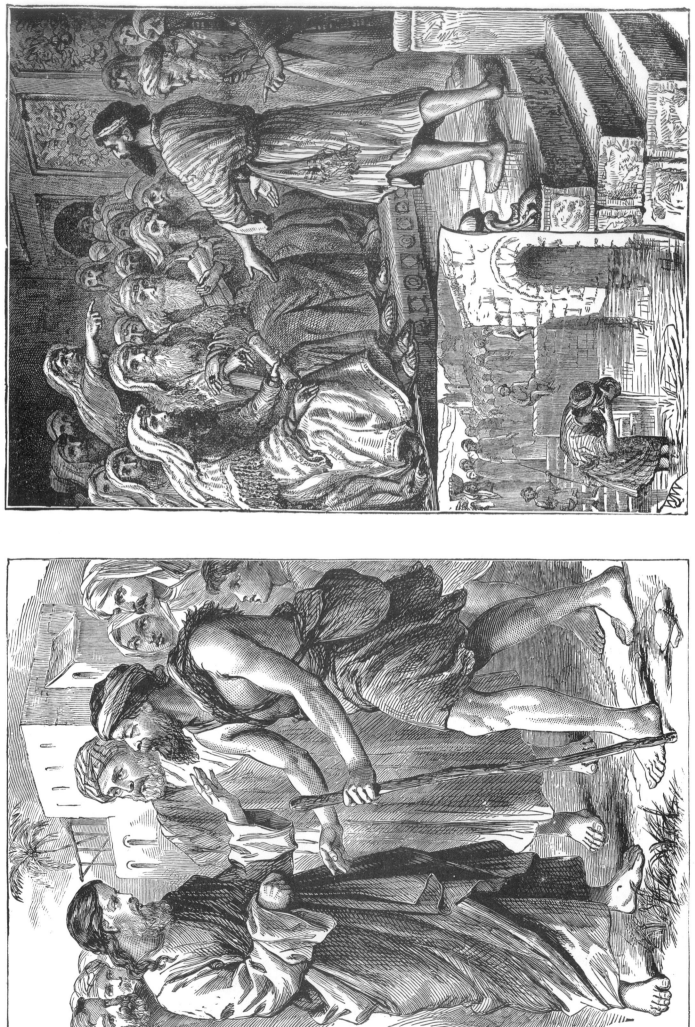

Fig. 230: "They said to him, 'Then how were your eyes opened?'" (9:10).

Fig. 228: "As he passed by, he saw a man blind from his birth." (9:1).

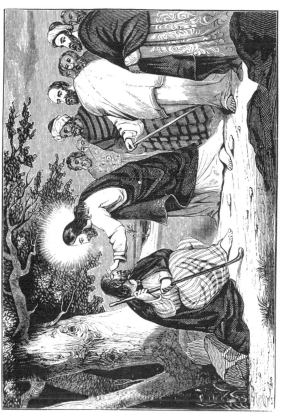

Fig. 229: "He spat on the ground and made clay of the spittle and anointed the man's eyes with the clay, saying to him, 'Go, wash in the pool of Siloam'" (9:6–7).

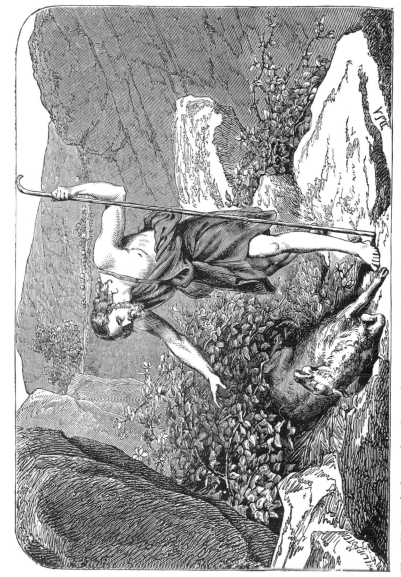

Fig. 232: "And I have other sheep, that are not of this fold; I must bring them also, and they will heed my voice'" (10:16).

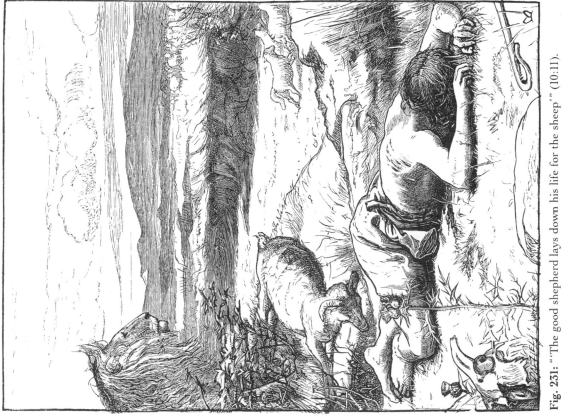

Fig. 231: "The good shepherd lays down his life for the sheep'" (10:11).

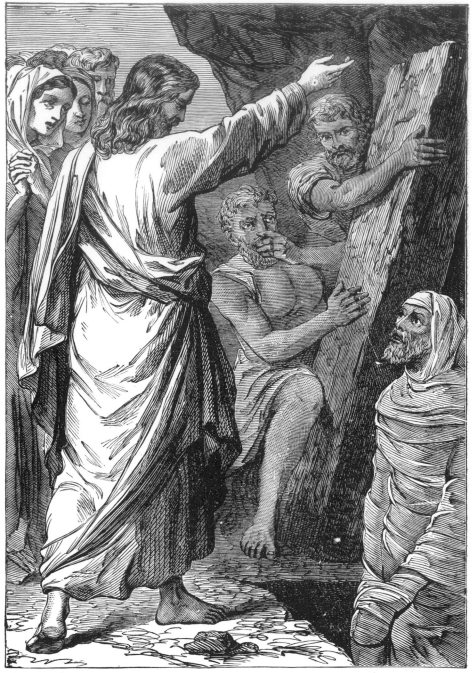

Fig. 233: The Raising of Lazarus at Bethany (11:43–44).

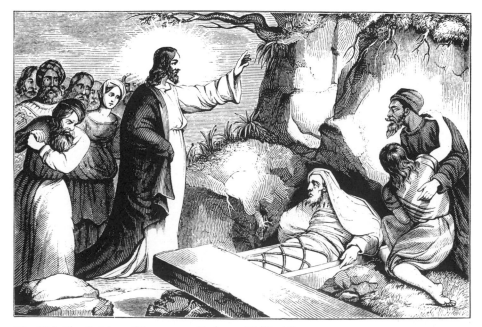

Fig. 234: The Raising of Lazarus at Bethany (11:43–44).

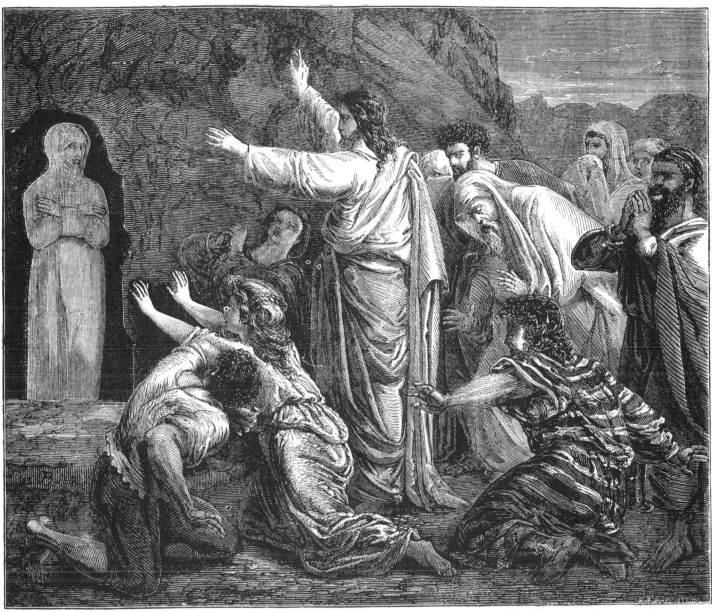

Fig. 235: The Raising of Lazarus at Bethany (11:43–44).

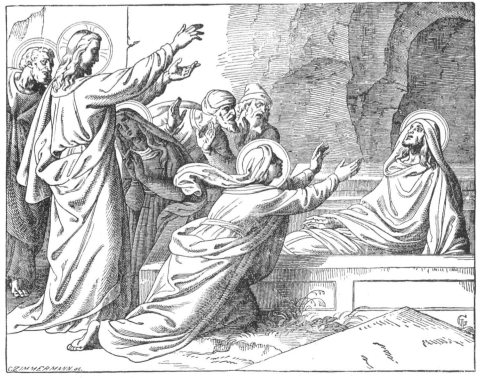

Fig. 236: The Raising of Lazarus at Bethany (11:43–44).

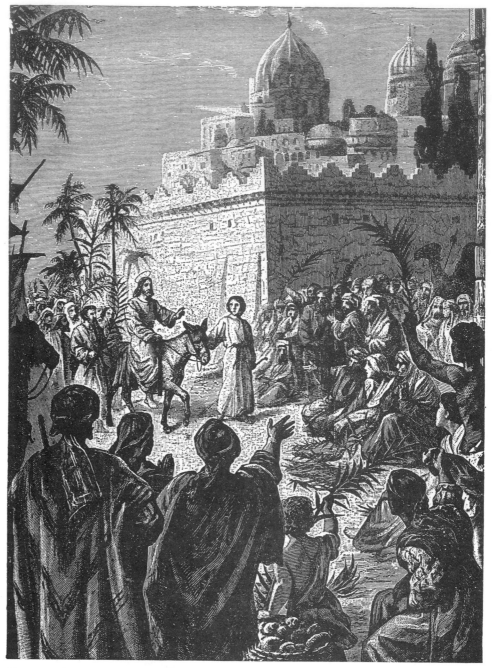

Fig. 237: The Entry into Jerusalem (12:12–15).

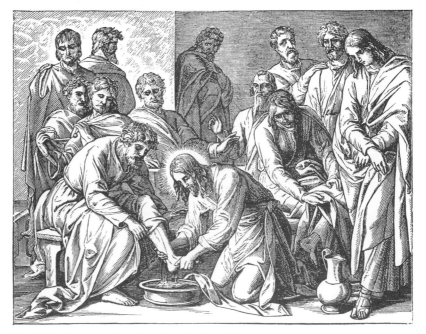

Fig. 238: Jesus washing the disciples' feet (13:5).

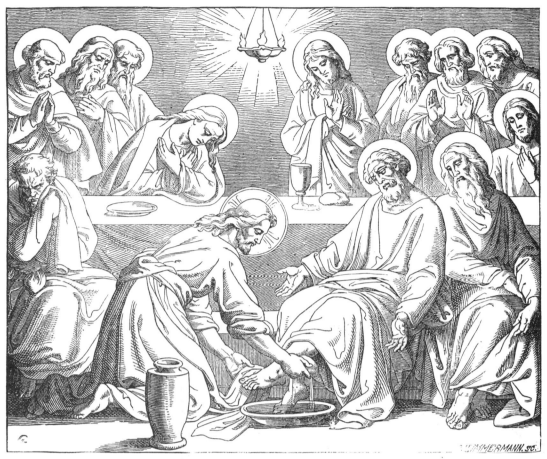

Fig. 239: Jesus washing the disciples' feet (13:5).

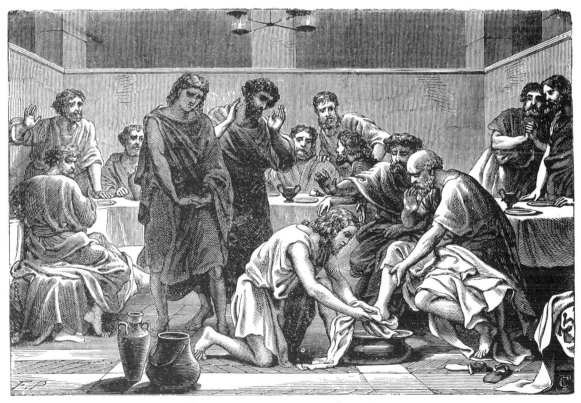

Fig. 240: Jesus washing Peter's feet (13:6–11).

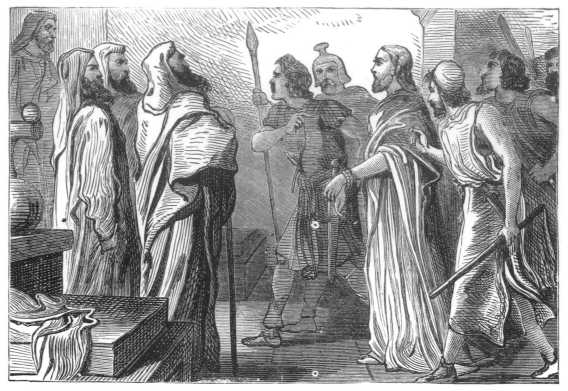

Fig. 241: Jesus before Pilate (18:33–38).

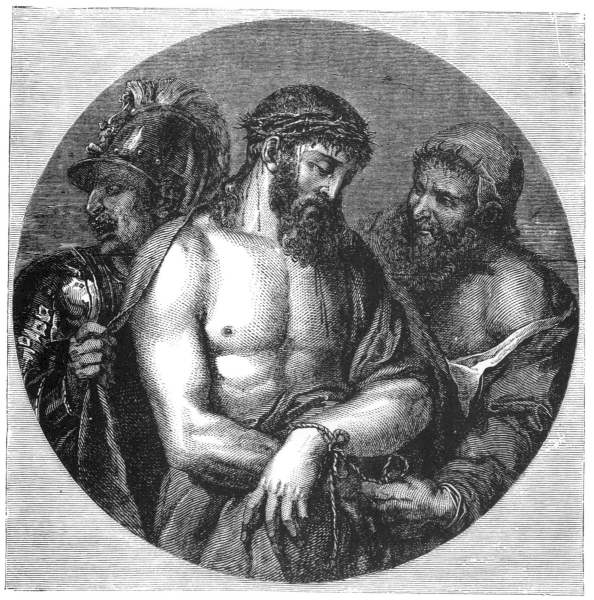

Fig. 242: Ecce Homo (19:5).

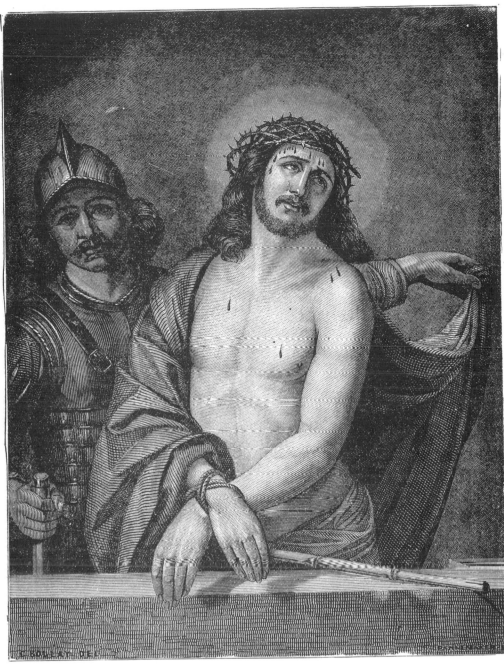

Fig. 243: Ecce Homo (19:5).

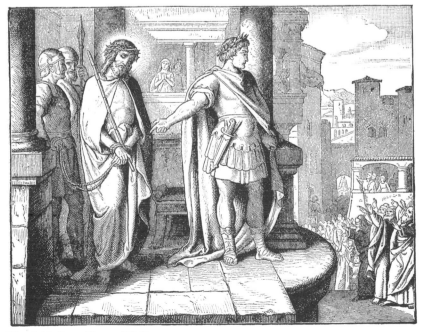

Fig. 244: Ecce Homo (19:5).

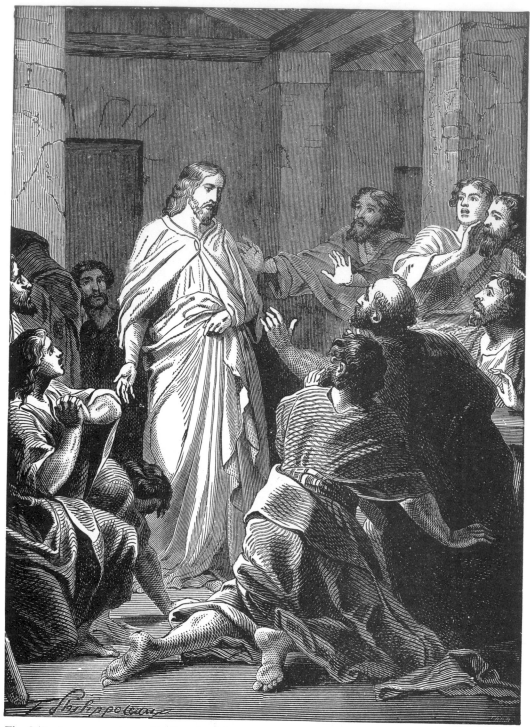

Fig. 245: Jesus appearing to his disciples (20:19–23).

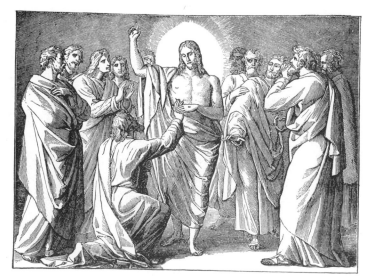

Fig. 246: The Incredulity of Thomas (20:26–29).

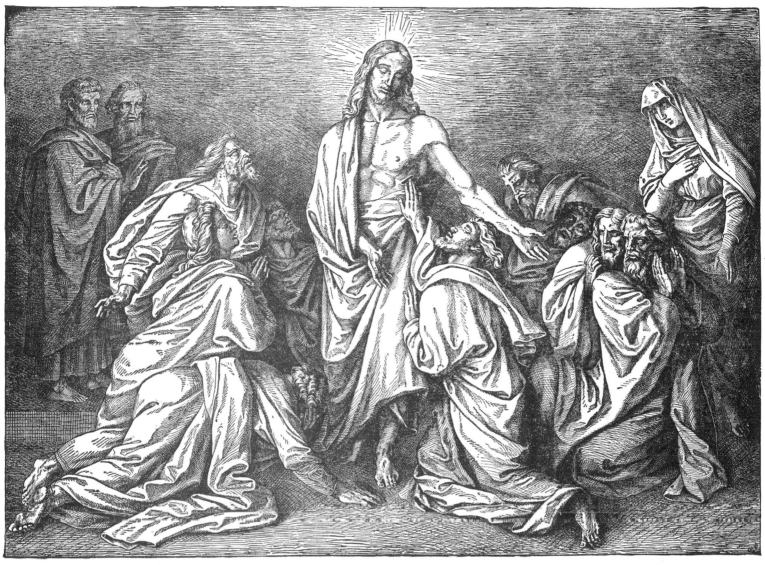

Fig. 247: The Incredulity of Thomas (20:26–29).

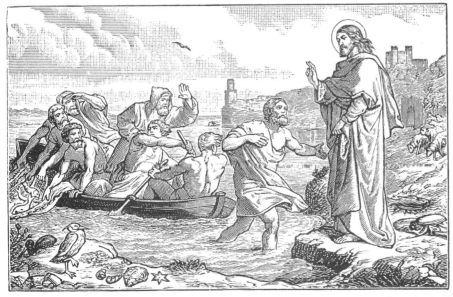

Fig. 248: Jesus appearing to his disciples by the Sea of Tiberias; the miraculous draft of fishes (21:4–8).

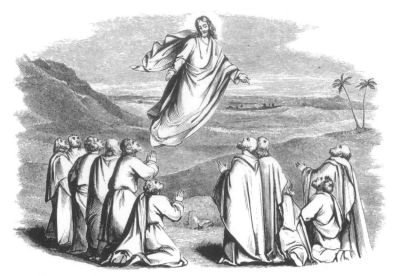

Fig. 249: The Ascension (1:9–11).

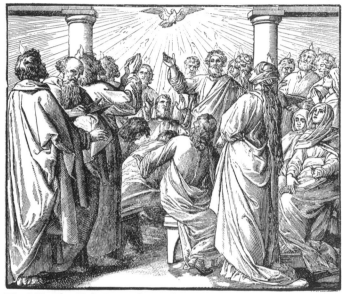

Fig. 251: The Holy Spirit descending on the disciples on the day of Pentecost (2:1–4).

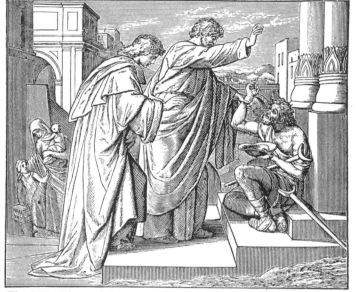

Fig. 253: John and Peter entering the Beautiful Gate; Peter healing the lame man (3:1–10).

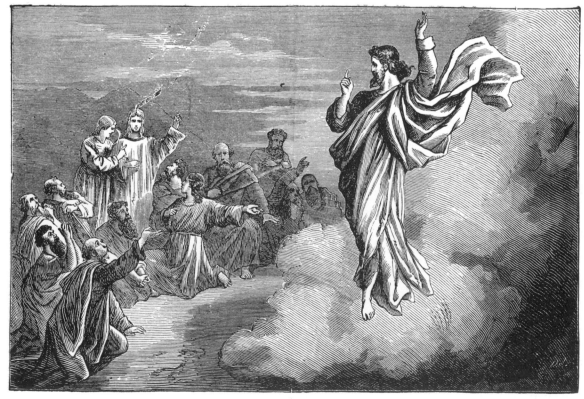

Fig. 250: The Ascension (1:9–11).

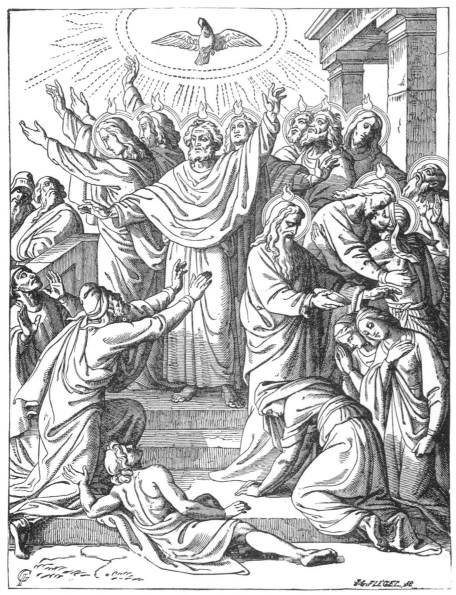

Fig. 252: The Holy Spirit descending on the disciples on the day of Pentecost (2:1–4).

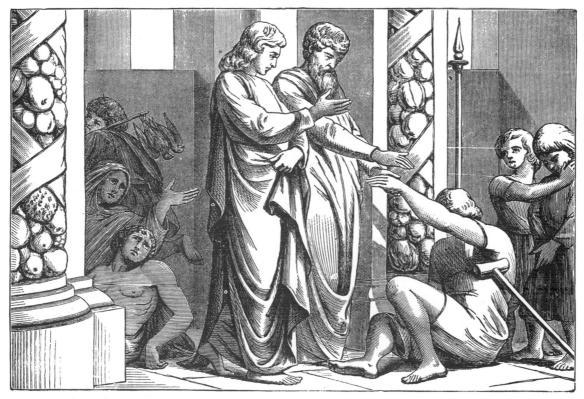

Fig. 254: John and Peter entering the Beautiful Gate; Peter healing the lame man (3:1–10).

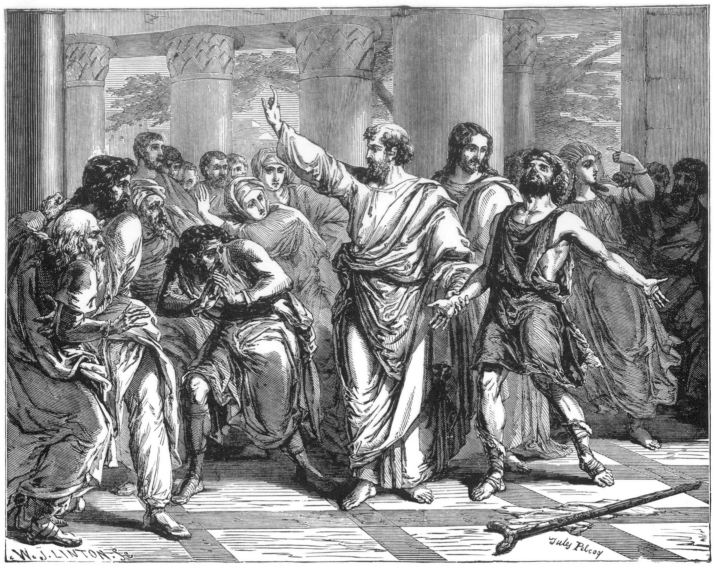

Fig. 255: John and Peter entering the Beautiful Gate; Peter healing the lame man (3:1–10).

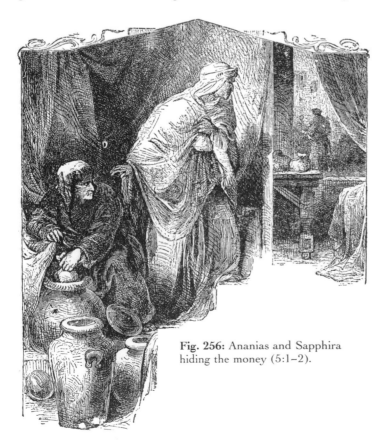

Fig. 256: Ananias and Sapphira hiding the money (5:1–2).

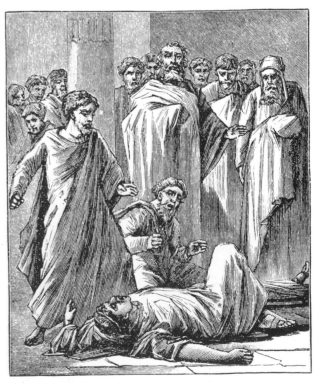

Fig. 257: The death of Ananias (5:3–6).

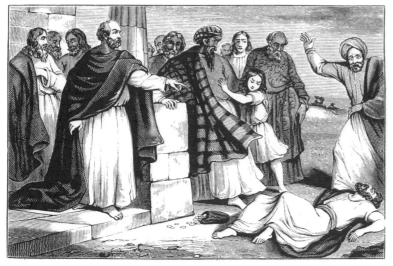

Fig. 258: The death of Ananias (5:3–6).

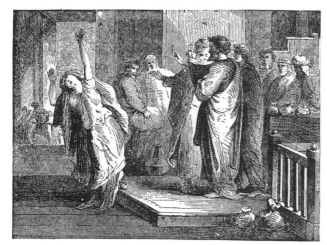

Fig. 259: The death of Sapphira (5:7–11).

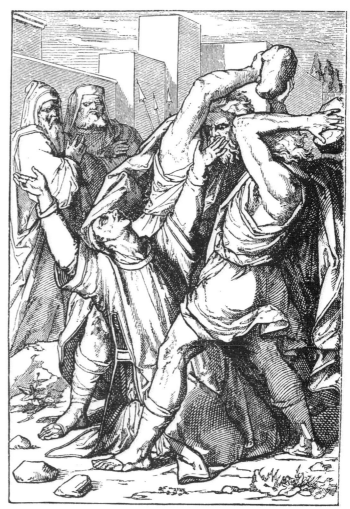

Fig. 261: The stoning of Stephen (7:58–60).

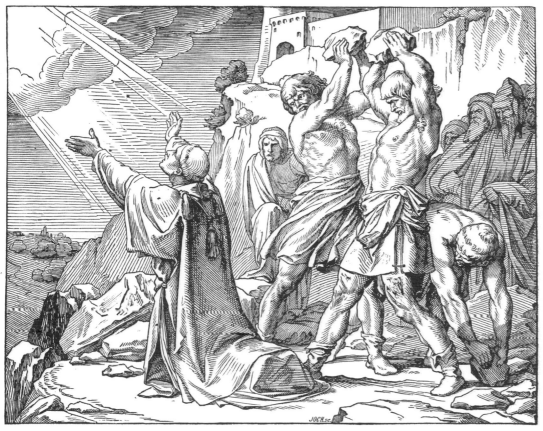

Fig. 260: The stoning of Stephen (7:58–60).

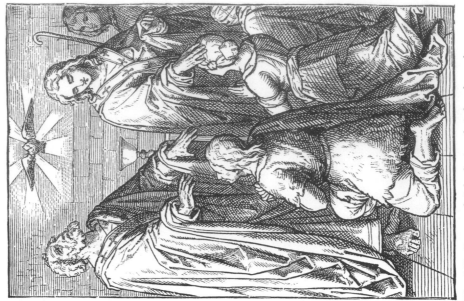

Fig. 263: Peter and John laying their hands on the Samaritans (8:14–17).

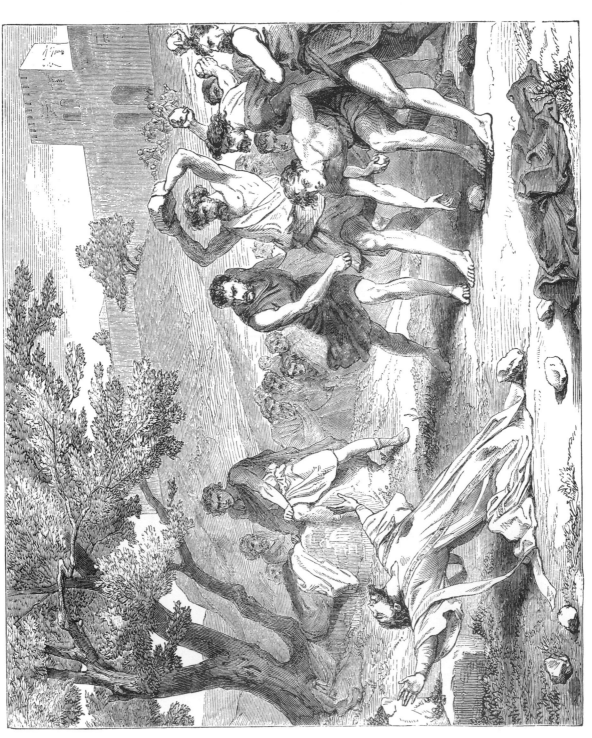

Fig. 262: The stoning of Stephen (7:58–60).

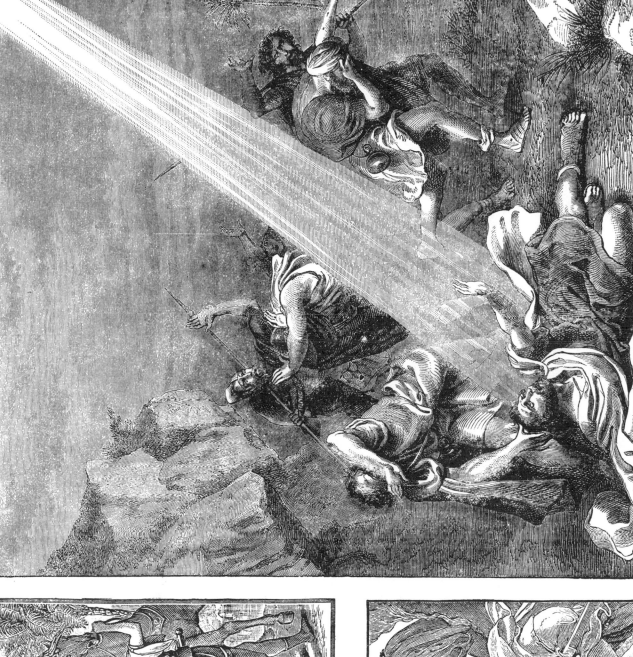

Fig. 266: The conversion of Paul (9:3–7).

Fig. 264: Philip and the eunuch (8:26–35).

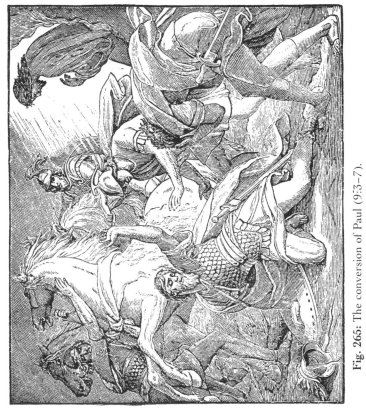

Fig. 265: The conversion of Paul (9:3–7).

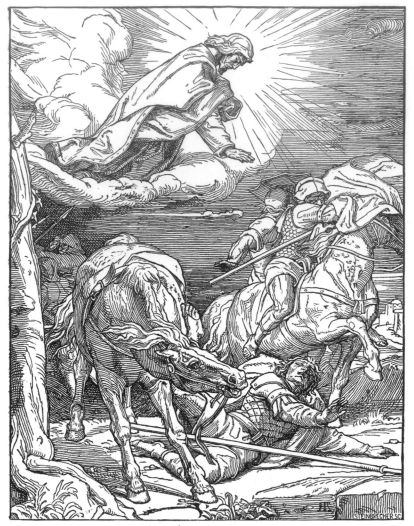

Fig. 267: The conversion of Paul (9:3–7).

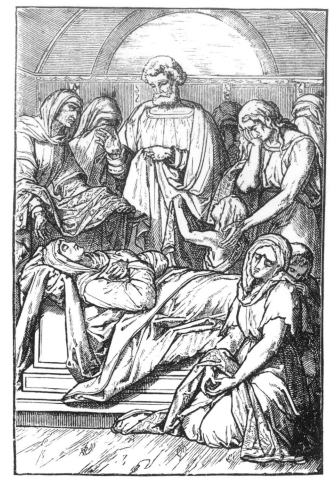

Fig. 269: The raising of Dorcas by Peter (9:36–42).

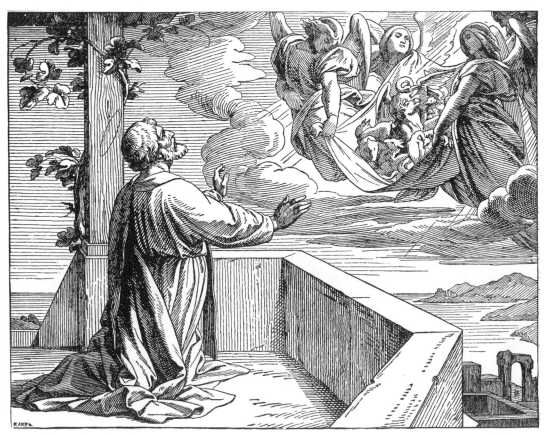

Fig. 270: Peter's vision on the housetop (10:9–16).

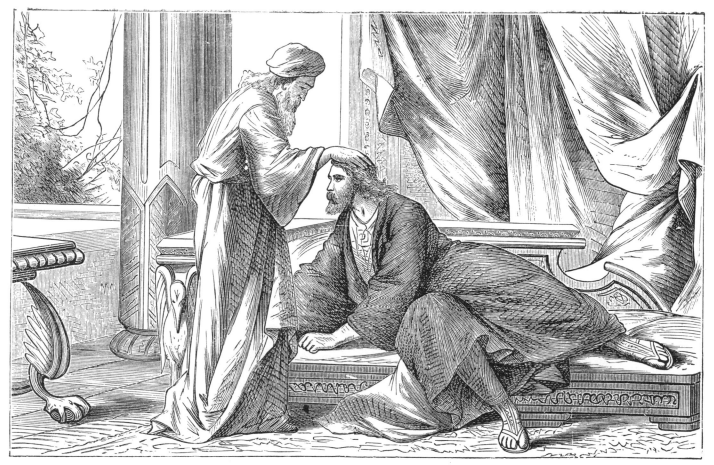

Fig. 268: Ananias restoring the sight of Paul (9:17–18).

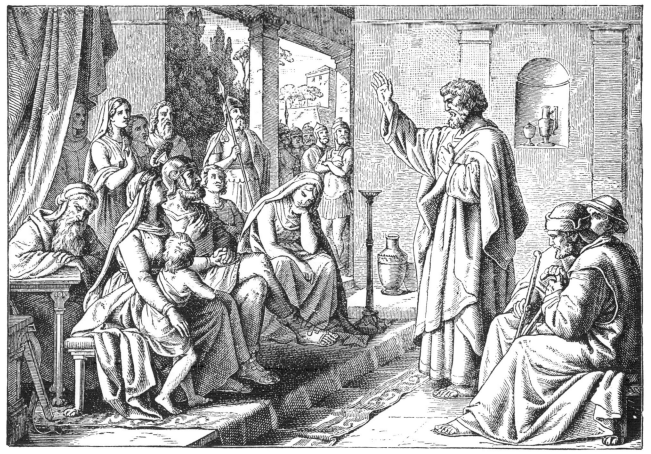

Fig. 271: Peter in the house of the centurion Cornelius (10:27–29).

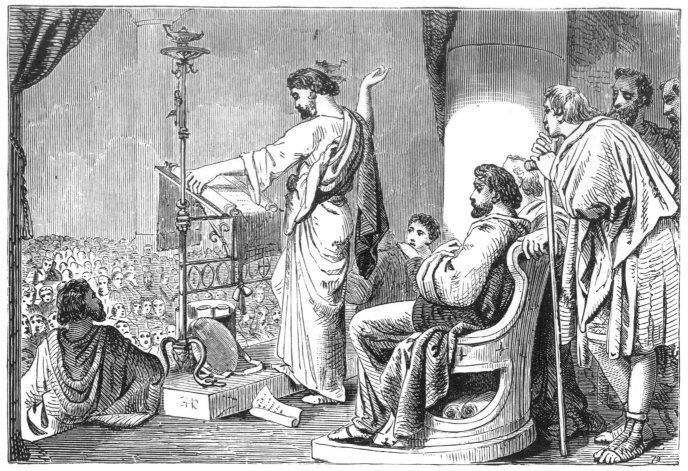

Fig. 272: Paul and Barnabas at Antioch (11:25–26).

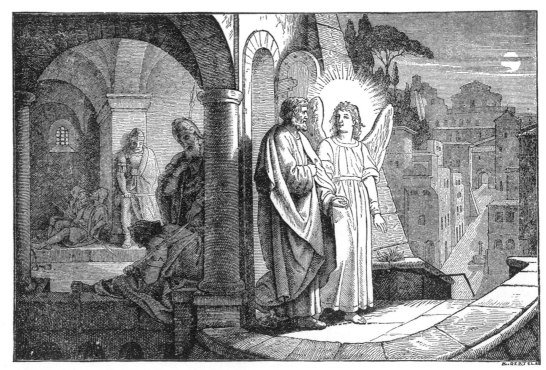

Fig. 273: The angel delivering Peter from prison (12:6–11).

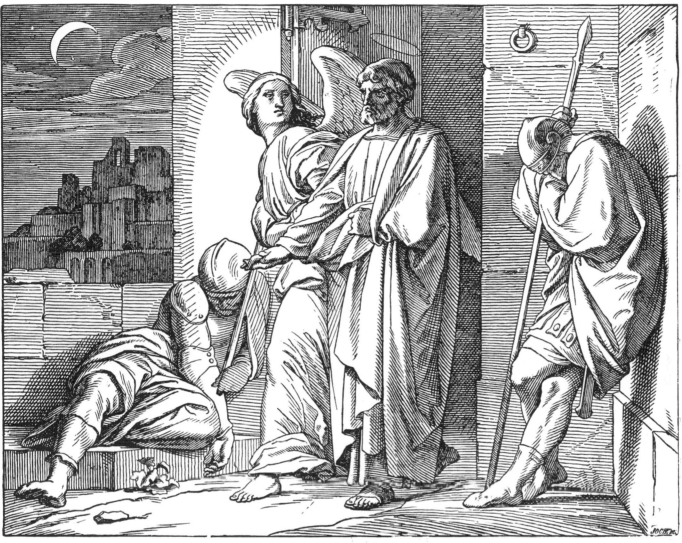

Fig. 274: The angel delivering Peter from prison (12:6–11).

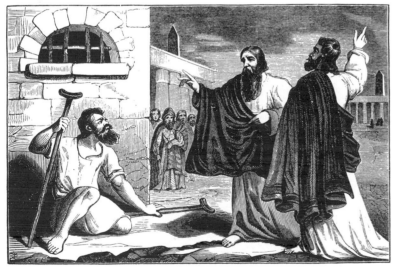

Fig. 275: Paul healing a cripple at Lystra as Barnabas watches (14:8–10).

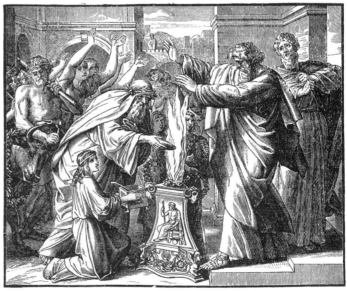

Fig. 276: The people preparing to offer sacrifice to Paul and Barnabas at Lystra (14:11–18).

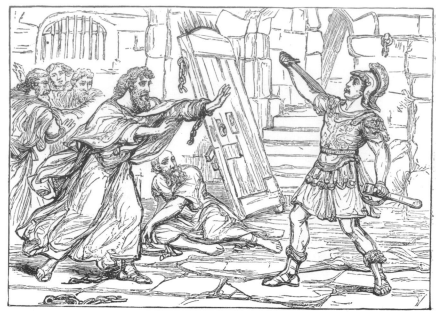

Fig. 277: "Paul cried with a loud voice, 'Do not harm yourself, for we are all here'" (16:28).

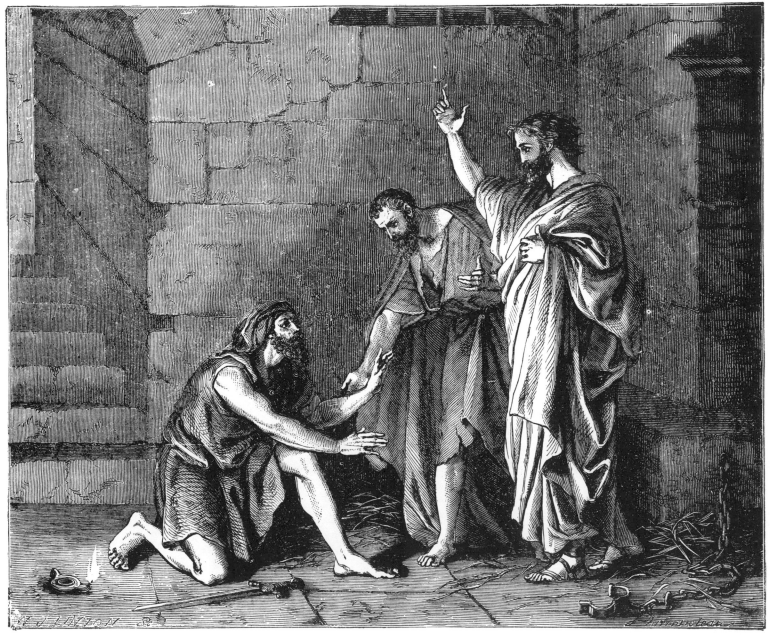

Fig. 278: The jailer asking Paul and Silas what he must do to be saved (16:29–31).

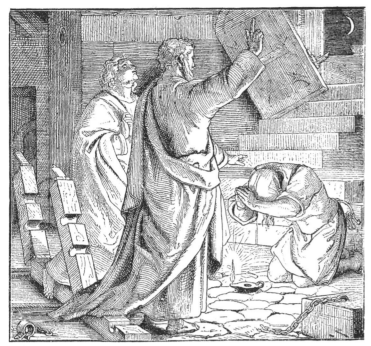

Fig. 279: The jailer asking Paul and Silas what he must do to be saved (16:29–31).

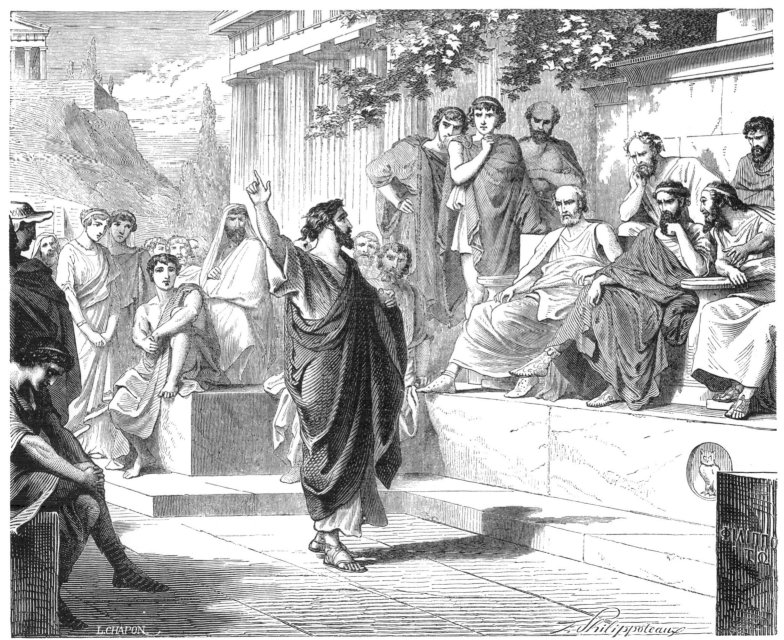

L.CHAPON

Fig. 280: Paul preaching at Athens (17:22–31).

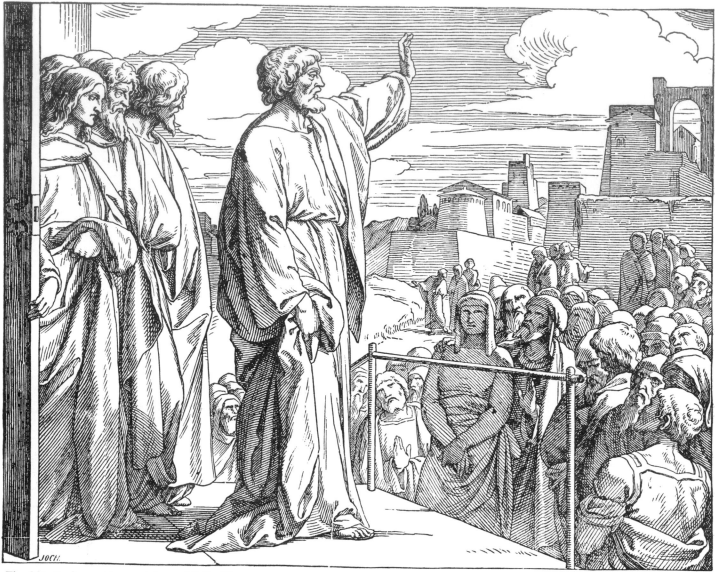

Fig. 281: Paul preaching at Athens (17:22–31).

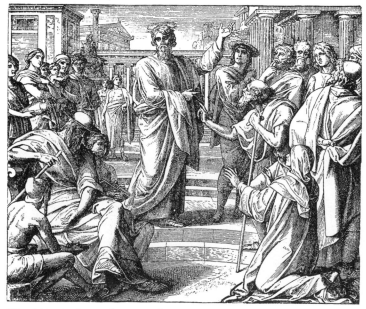

Fig. 282: Paul preaching at Athens (17:22–31).

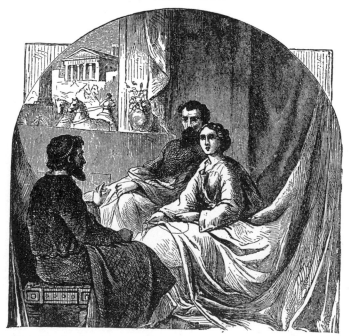

Fig. 283: Paul visiting Aquila and Priscilla in Corinth (18:1–2).

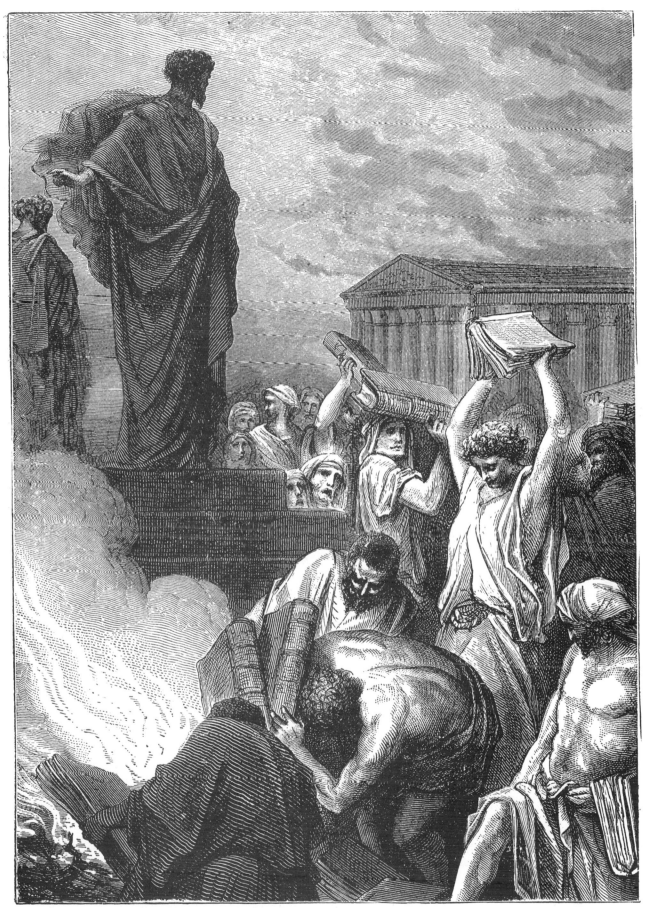

Fig. 284: The Ephesians burning their books (19:19).

Fig. 286: Demetrius inciting the Ephesians against Paul (19:23–27).

Fig. 285: The Ephesians burning their books (19:19).

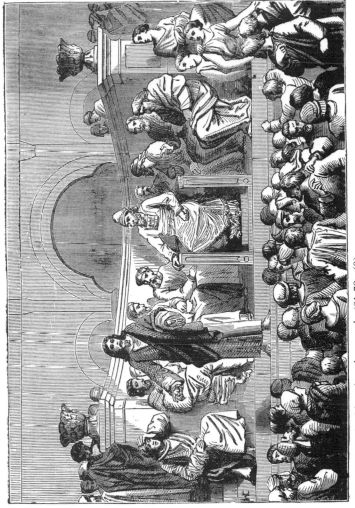

Fig. 288: Paul parting with the elders at Miletus (20:36–38).

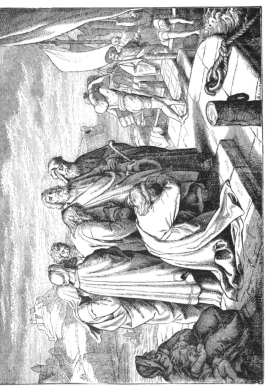

Fig. 290: Paul addressing the people (21:39–40).

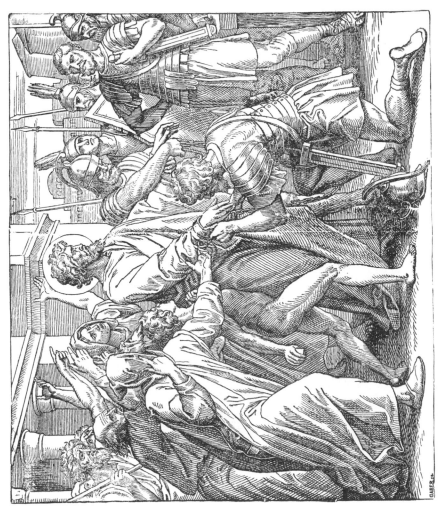

Fig. 289: The arrest of Paul (21:33).

Fig. 287: Paul parting with the elders at Miletus (20:36–38).

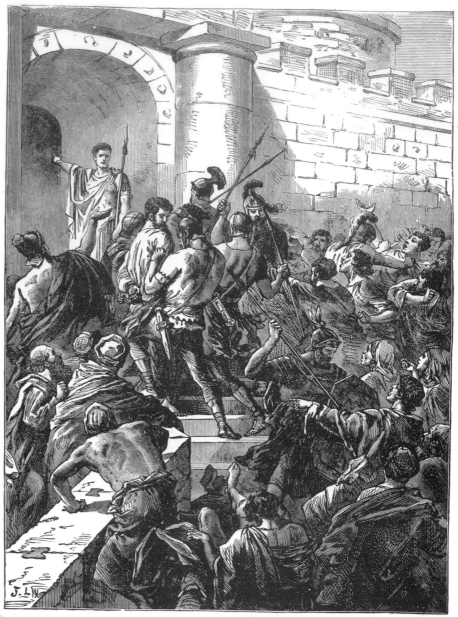

Fig. 291: The soldiers bringing Paul into the barracks (23:10).

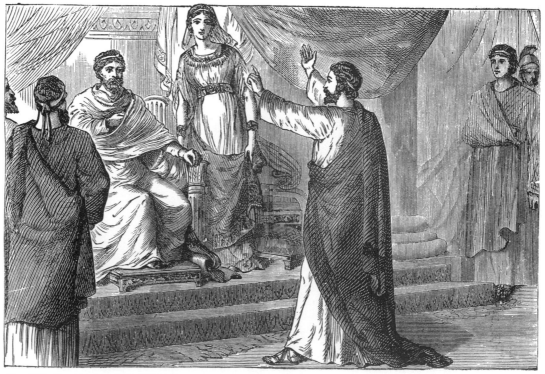

Fig. 292: Paul before Felix (24:10).

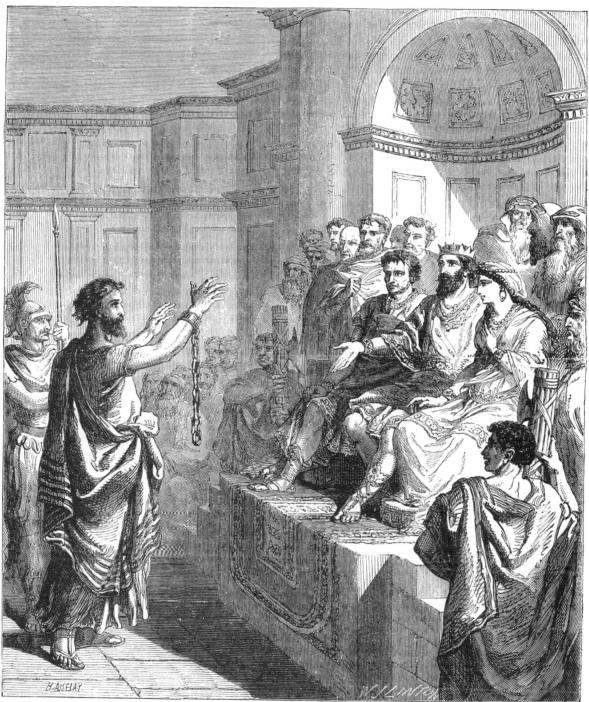

Fig. 293: Paul before Agrippa (26:1).

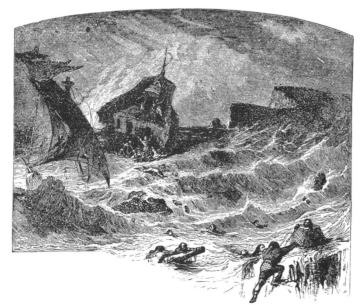

Fig. 294: Paul shipwrecked on the island of Malta (27:39–44).

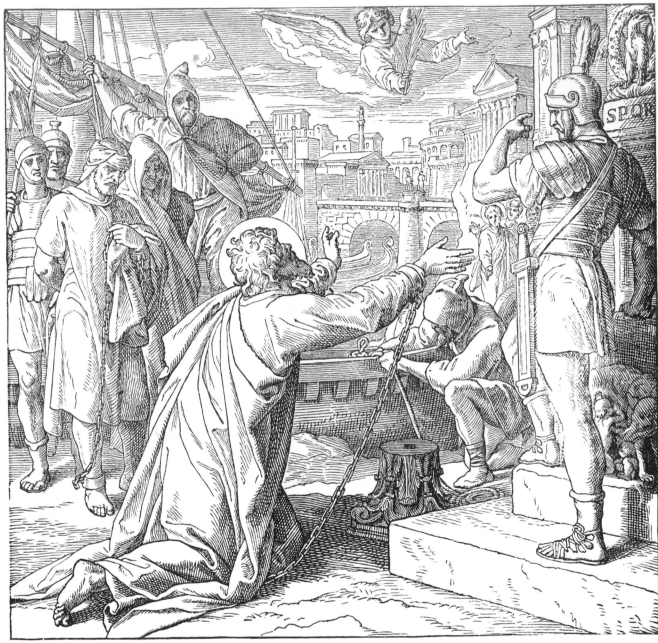

Fig. 295: Paul bound with chains in Rome (28:20).

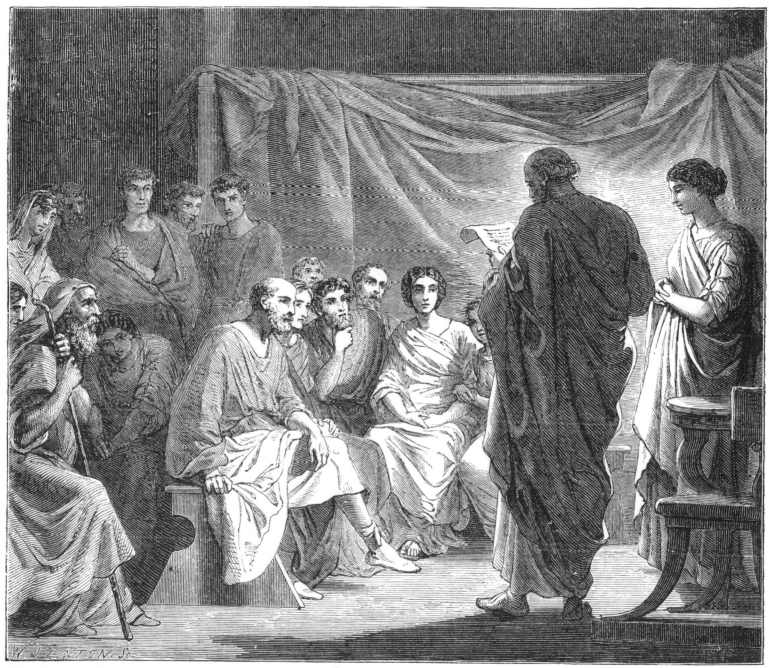

Fig. 296: Early Christians in Rome listening to a reading of the epistle of Paul (Rom. 1:7).

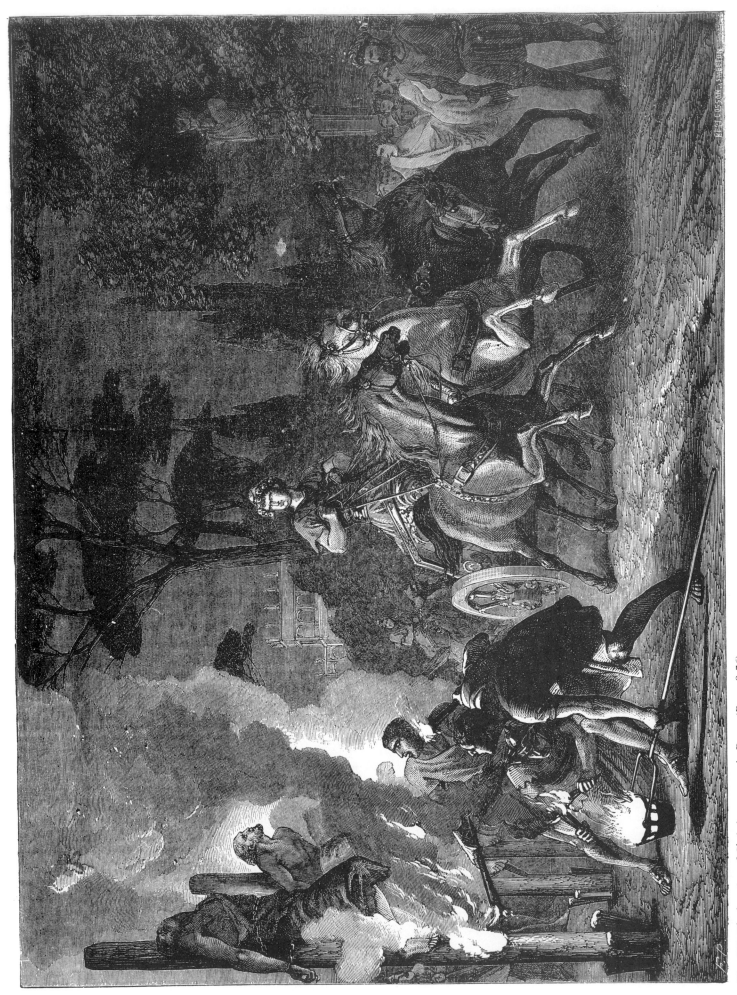

Fig. 297: The burning of Christian martyrs in Rome (Rom. 8:36).

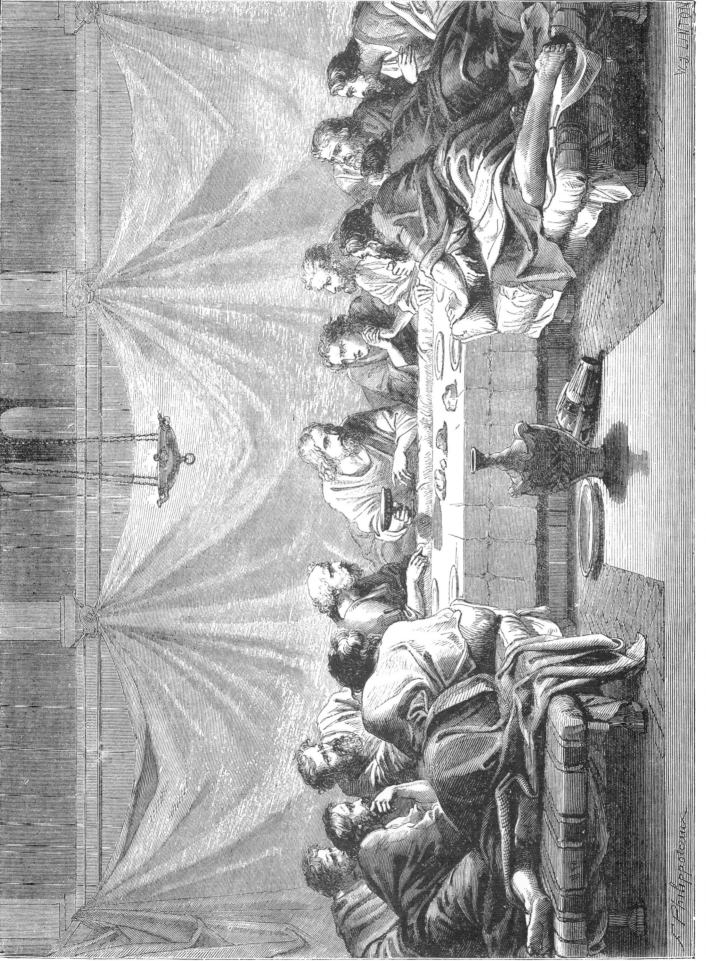

Fig. 298: "'This cup is the new covenant in my blood. Do this, as often as you drink it, in remembrance of me'" (1 Cor. 11:25).

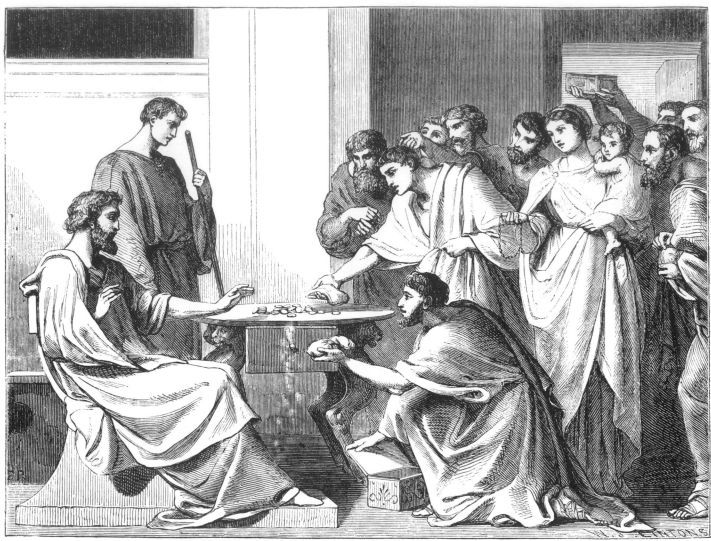

Fig. 299: The Macedonians presenting gifts to Paul (2 Cor. 8:1–5).

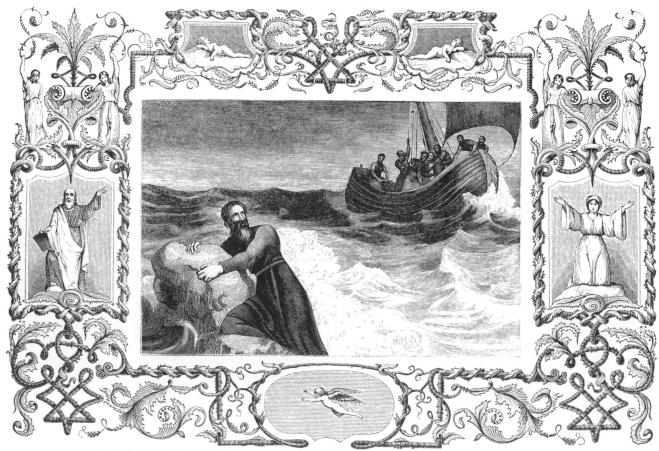

Fig. 300: Paul adrift at sea (2 Cor. 11:25).

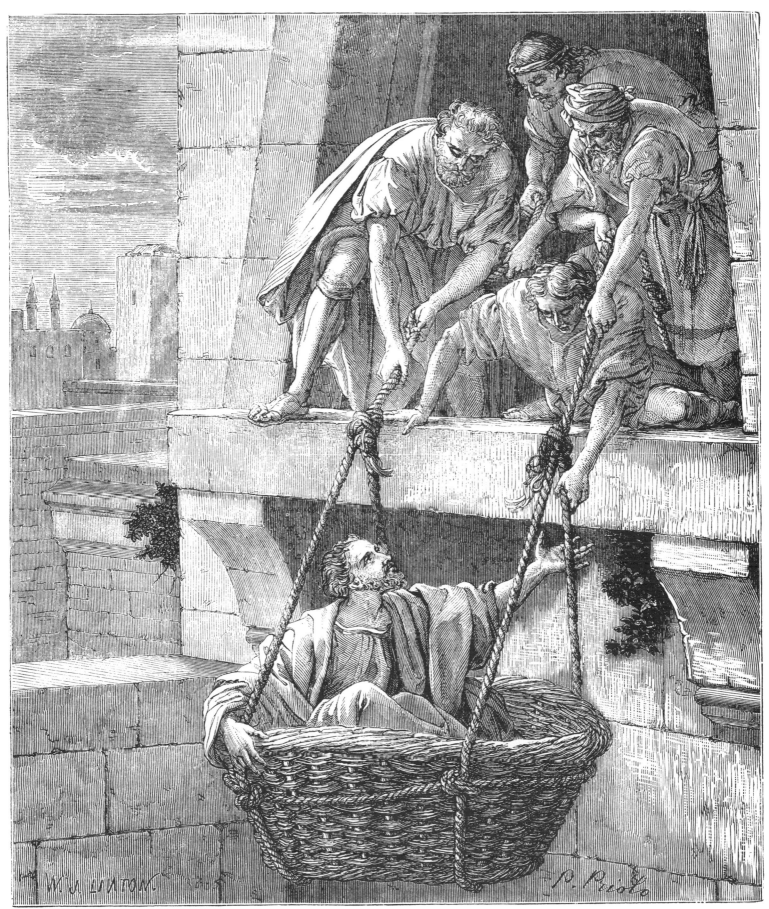

Fig. 301: Paul let down in a basket (2 Cor. 11:32–33).

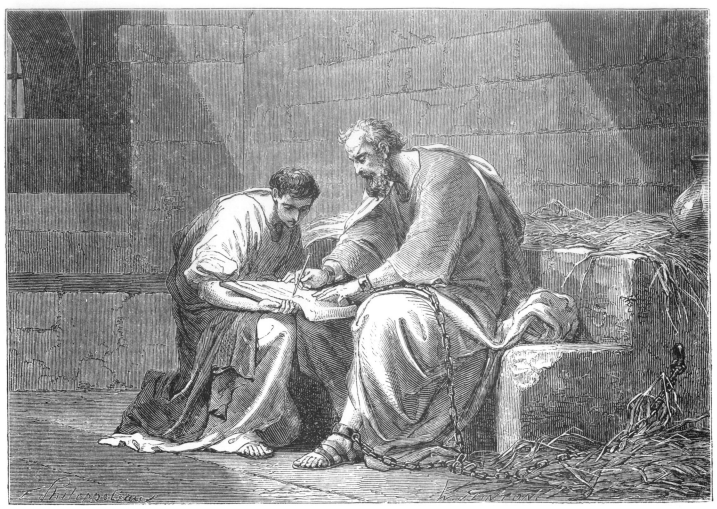

Fig. 302: Paul in prison writing his epistle to the Ephesians (Eph. 3:1–6).

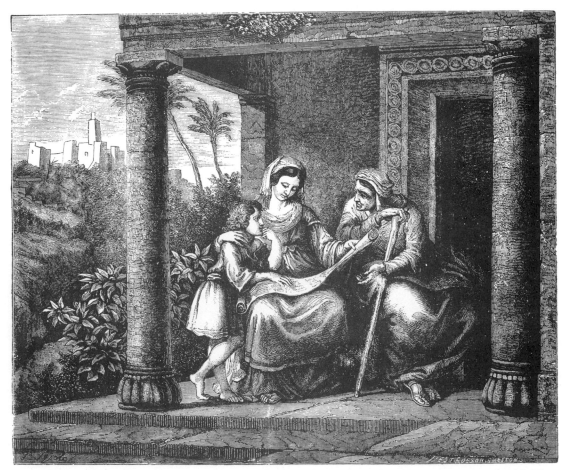

Fig. 303: Timothy reading the sacred writings with his mother and grandmother (2 Tim. 1:5 and 3:14–15).

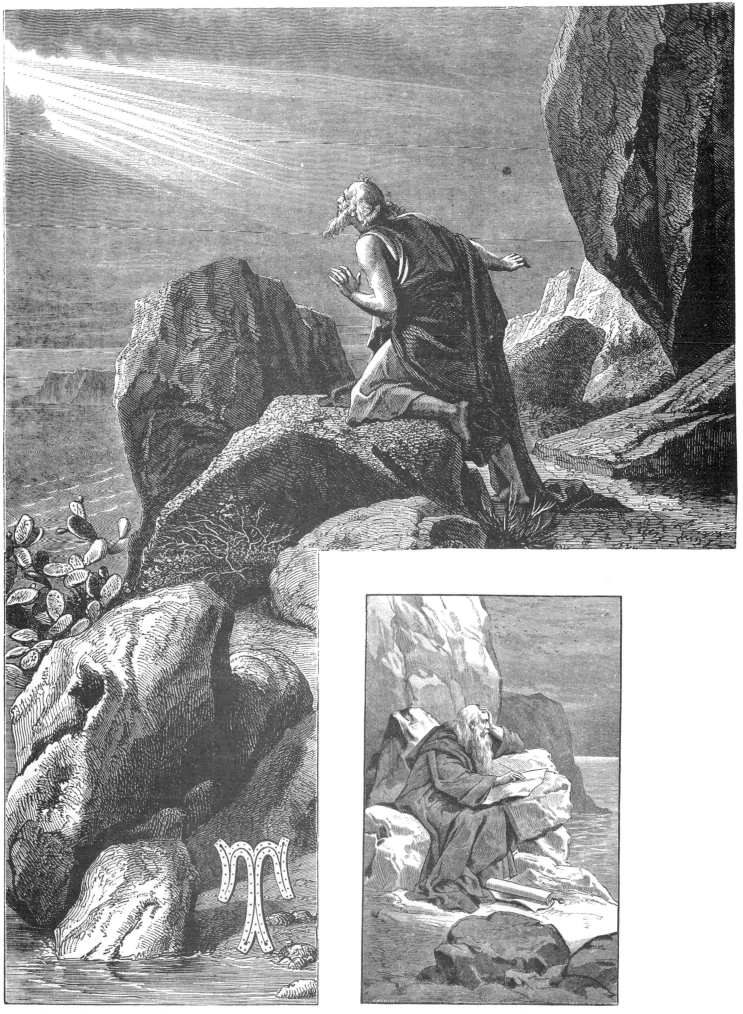

Fig. 304: St. John on the island of Patmos (1:9–11).

Fig. 305: St. John on the island of Patmos (1:9–11).

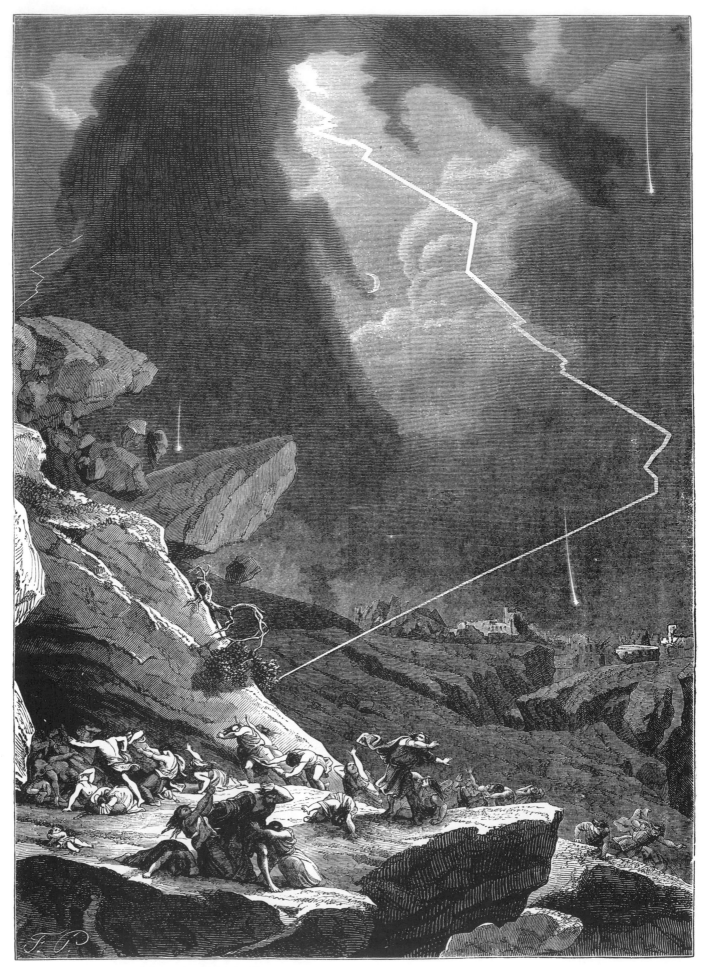

Fig. 306: The opening of the sixth seal (6:12–17).

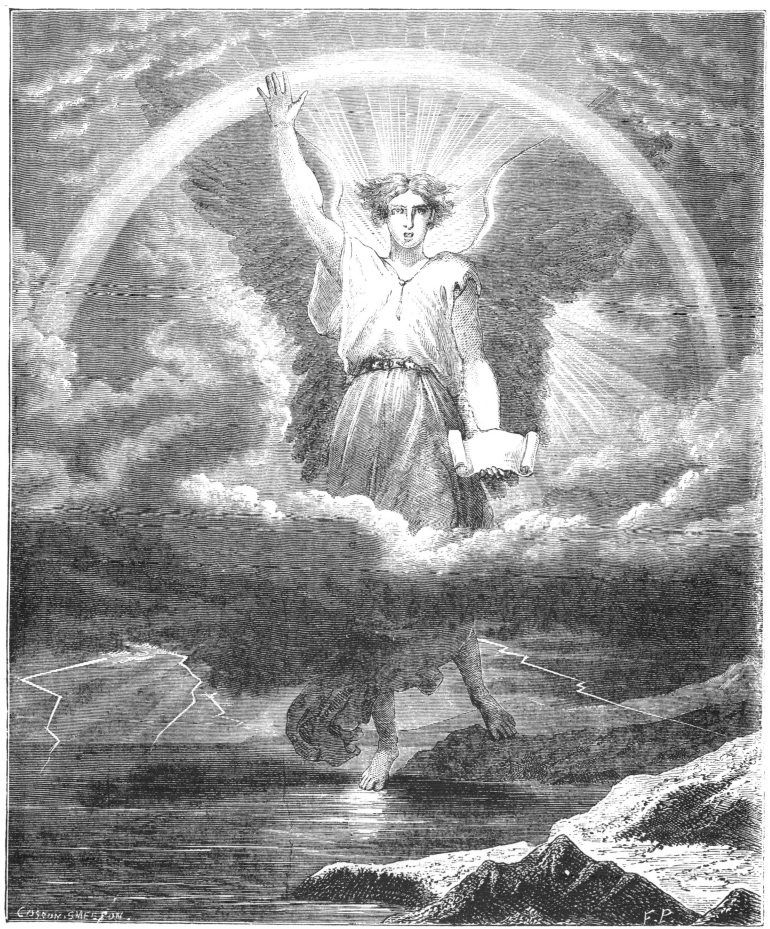

Fig. 307: The angel standing on sea and land (10:1–7).

Fig. 308: The resurrection of the two prophets (11:11–12).

Fig. 310: "'So shall Babylon the great city be thrown down with violence, and shall be found no more'" (18:21).

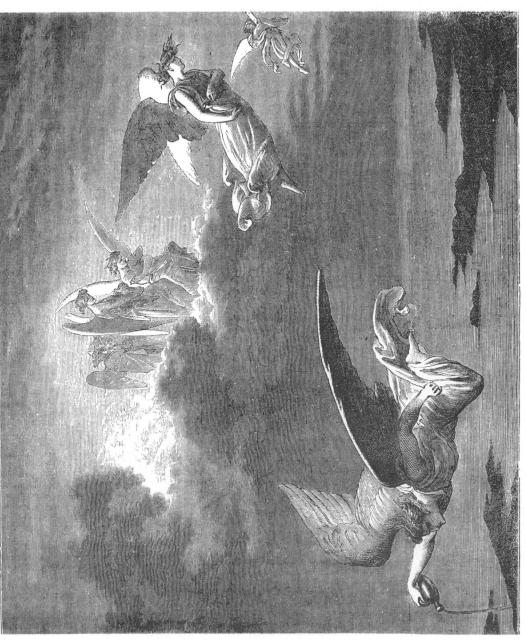

Fig. 309: The seven angels with the seven plagues (16:1).

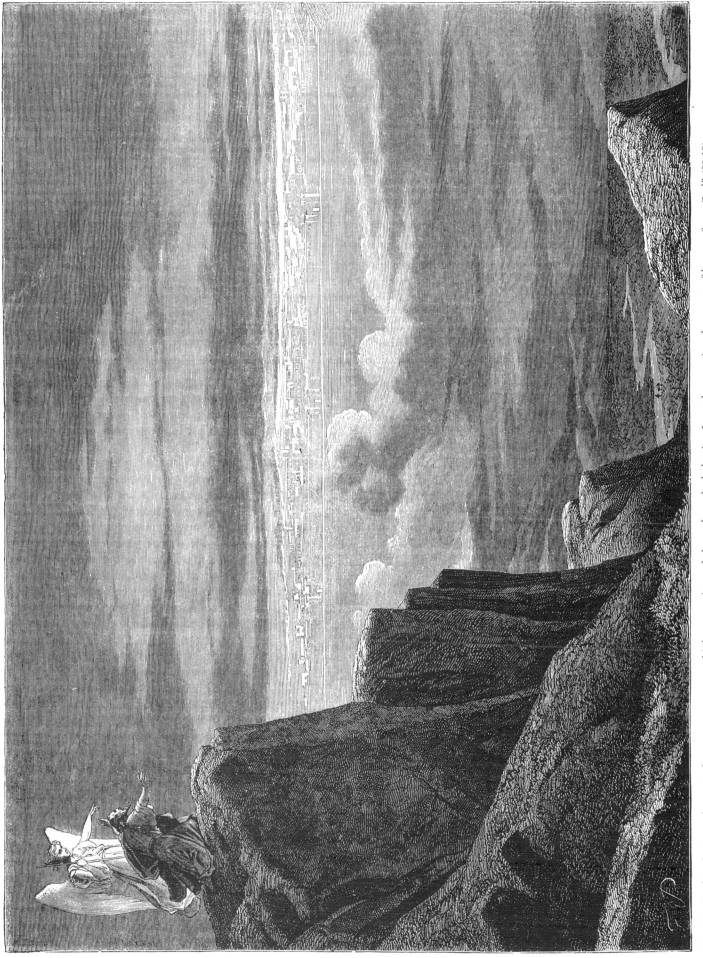

Fig. 311: "And in the Spirit he carried me away to a great, high mountain, and showed me the holy city, Jerusalem coming down out of heaven from God" (21:10).

INDEX

The numbers are those of the illustrations.